AMPHOTO
an imprint of Watson-Guptill Publications/New York

Copyright © 1986, 1988, by J. Barry O'Rourke

First published 1986 in New York by AMPHOTO,
an imprint of Watson-Guptill Publications,
a division of Billboard Publications, Inc.,
1515 Broadway, New York, NY 10036

Library of Congress Cataloging-in-Publication Data

O'Rourke, J. Barry.
 How to photograph women—beautifully.

 Includes index.
 1. Photography of women. I. Title.
TR681.W6076 1986 778.9'24 85-30641
ISBN 0-8174-4003-8
ISBN 0-8174-4004-6 (pbk.)

Manufactured in Japan

11 12 13 14 15 16/03 02 01 00 99 98

How to Photograph
WOMEN
Beautifully

How to Photograph
WOMEN
Beautifully

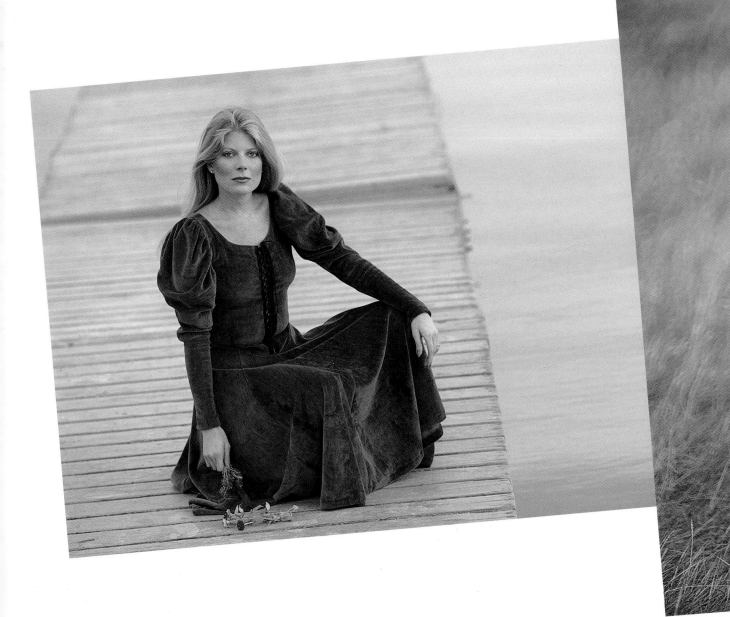

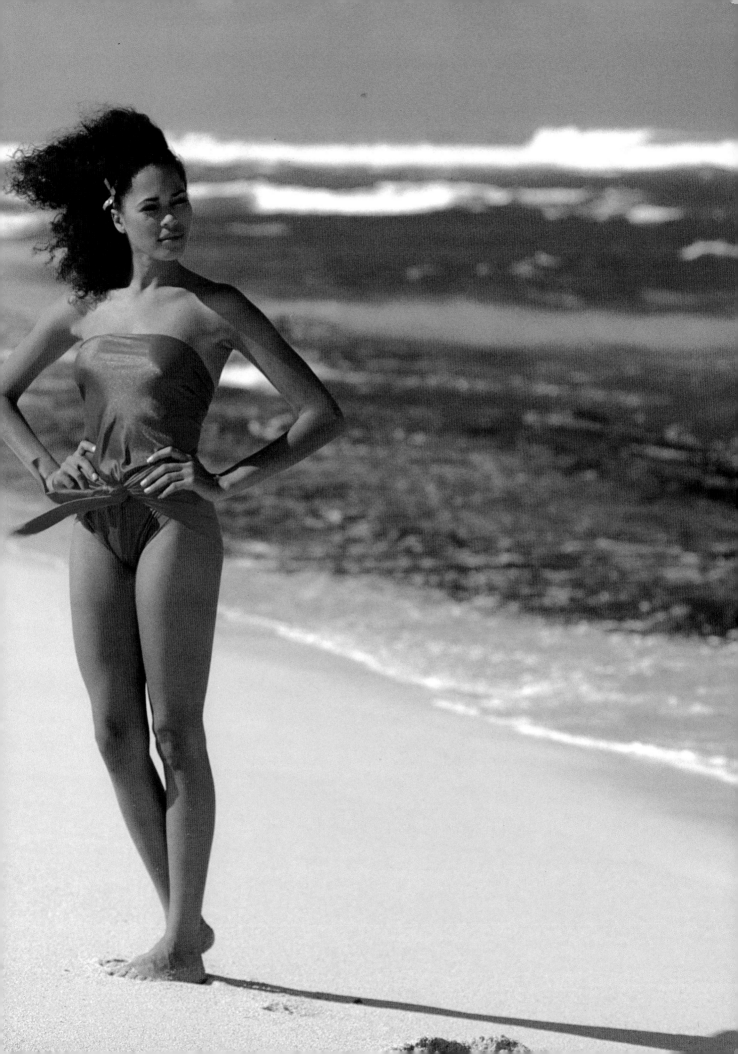

ACKNOWLEDGMENTS

I would like to thank everyone who helped make this book possible:
the models—Marjorie Andrade, Tobi Bruce, Maureen Campbell, Candace, Nancy
Doll, Mary Duffy, Pam Enz, Erika, Francoise, Dawn Gallagher, Colleen Gray, Brenda
Harris, Diane Hawkins, Shari Hilton, Leah Jensen, Belinda Johnson, Nerine Kidd,
Carol Kurzin, Donna Lee Roth, Sheri Montgomery, Mya, Gail Ogden, Toni O'Reilly,
Kathy Padin, Patti Quinn, Andrea Ross, Tracy Ross, Cynthia Shaffer, Shannon, Jane
Scotti, Vonnie, Lydia Wendt, Laura White, John Albert, Gary Byers, Phil Coccioletti,
Mac Lambert, Duke Lyskin, Pat Quinn, Mike Welch, and Tom Fitzsimmons; their
agencies—Big Beauties, Diva, Elite, Faces, Ford, H.V., McDonald/Richards,
Wilhelmina, and Zoli; the hair and makeup artists—Loraine Altamura, Patricia
Bowden, Clorinda, Rick Caldwell, Leonado De Vega, Garcia, Elizabeth Fried, Robert
La Courte, John Michael, Jorge Napoleon, John Pierro, Quintin Quintero, Letha
Rodman, Tomas Rodriquez, Jody Polutro, and Mark Schwartz; the stylists—Jocelyn
Braxton, Debbie Donahue, Veronica Reilly, and Marilyn Rodan; my assistants—
Robert, Randy, David, John, and Ray, to whom I owe special thanks; and finally, special
thanks to Monica—studio manager, organizer, booker, planner, chief cook and bottle
washer—without whom I would still be pulling this book together.

INTRODUCTION

I started photographing women in high school, taking my Brownie Flash Six–20 to school functions, parties, and on dates. I tried to do my best—which, at that time, was awful. After a four-year stint in the United States Navy as a motion-picture specialist in high-speed, guided-missile photography, I enrolled at the Art Center College of Design in Los Angeles, California, as a photojournalism major. After graduation I spent one year as an assistant for Dale Healy, a busy Los Angeles photographer.

Dale was a great teacher and businessman. I learned more from him in that one year than I did the last several semesters at school. I would have stayed with him longer, but the average assistant's wage at the time was a dollar an hour. Since I couldn't support my family on that salary, I went back to driving a cab in Hollywood at night, as I had when I was a student. During the day, I tried to pursue my career in magazine photography, sending ideas into national magazines and shooting picture stories without assignments and then trying to sell them. Will Connell, one of the grand old men of magazine photography, with whom I had studied at the Art Center, had warned us that in order to be successful in the field, you had to submit at least ten ideas a week to various publications. *Life*, *Look*, and *The Saturday Evening Post* were the big three, and I constantly sent them ideas. I finally joined Globe Photos, a picture agency that would sell your stories or obtain an assignment from your idea. They also received assignments as an agency, but those usually went to their more established photographers. For the first few years I was with Globe, I had to submit completed stories to them. After I proved that I could photograph a salable story, they would sell my ideas without my having to photograph them first.

I was able to quit driving a cab after a year because my wife, Carol, and I bought a "camera girl" concession in the New Ginza, a Japanese night club in the Little Tokyo section of downtown Los Angeles. This type of concession was very popular at the time in all the major clubs. Carol would take pictures at the tables and I would process and print a complete set of ten different-sized prints in six or seven minutes. I had to get everything printed during the floor show so she could sell them before the customers left. It was a very hectic existence, in more ways than one.

During the day Carol worked as a receptionist, while I tried to get a studio and a career off the ground. Between the day and night jobs we would have a couple of hours with our children before leaving them with the sitter again. I must say that after putting me through college and then working day and night while I got a start, at times my wife had more faith in me than I did.

Although I really wanted to be a photojournalist, I knew this was a very impractical career choice since I had a growing family to support. I decided to concentrate on becoming a general magazine photographer, and photographing women made up a large percentage of that business.

During this period I was sharing a studio with another photographer. I did composites and portfolio photographs for budding actresses and models as a way to pick up rent money. Every so often one of these kids would be pretty enough that I would submit her photograph for a cover or she might have an interesting hobby to use for an article. One girl actually led me, indirectly, to my first assignment with *Playboy*.

I had taken a few photographs for her book and later ran into her at the Santa Barbara road races where she was functioning as part of the pit crew for a friend. Since I was a car nut at the time, I knew that Carroll Shelby was building his own car with an English AC Bristol and a Ford drive train. I put the two circumstances together and did a story featuring Shelby giving the model driving lessons in the new Shelby Cobra. *Playboy* didn't want the story (which sold to a couple of general interest magazines at the time), but they assigned me to do a story on just the car. But it was actually an architectural shoot that brought me to the attention of Vince Tajiri, who was *Playboy*'s picture editor at the time.

My "bread-and-butter" work had become architectural photography. To this day, I still feel that it is the best way to learn the discipline required to be a good photographer. Shooting interiors and exteriors with a view camera does not allow for mistakes, and most jobs were done without the use of Polaroid test shots. Each angle or view was only photographed twice—on two sheets of color film—which was the most any architectural firm or magazine would pay for at the time.

While I was working for some architectural firms, I got to know a number of their draftsmen, who were graduate architectural students working on their required apprenticeships. One of these architects-to-be, Fred Lyman, had designed and built himself an unusual bachelor house on the coast near Malibu. I did a feature on the house, and Globe sold the idea to *Playboy*, whose only provision was that I go back and expand the shooting, which I did. Or, at least, I thought I had at the time.

One of the major shots involved a difficult exposure involving setting sun, candle light, and synchronized flash. I managed to pull off four shots, which, compared to what I normally provided my architectural clients with, I felt was a magnanimous amount. Needless to say, I was surprised when Tajiri, who was later to become a close friend, called and asked to see the rest of the take. Although the story was published, I quickly learned that the average professional assignment can yield anywhere from a couple of rolls to over a hundred.

Several months later, on a trip to New York City, I

INTRODUCTION

stopped in Chicago to show Tajiri my portfolio. A week later he offered me a staff position (we had a gentleman's agreement that I was not to become a centerfold photographer) and we still get a kick out of my first major consumer magazine shooting, for which I turned in four shots!

I spent four terrific years in Chicago with *Playboy*, photographing everything from sports cars, men's fashion, and travel layouts to the Bunnies and Hugh Hefner. It was a hell of an education—the magazine was growing so rapidly during the mid-Sixties that we seldom went more than a day without photographing something. There were six staffers (myself, Jerry Yulsman, Mario Casilli, Alexas Urba, Pompeo Posar, and Larry Dale Gordon)—four in Chicago, one in New York City, and one in Los Angeles— and we were all caught up in the tremendous excitement of working for the fastest-growing magazine in the history of publishing. I have to chuckle now when I look back and think of how overworked and underpaid we were. But back then it didn't matter; it was an incredible experience just to go to work every day and find out what you would be doing and where you would be going next.

If you were a Chicago staffer shooting in Los Angeles, you were expected to be on the "red-eye" flight the night you finished the shoot, so that you could be back in the office the next day—just in case there was another assignment. It was not unusual to do a fashion spread in Palm Springs for three or four days, stop in Santa Barbara on the way to photograph an author, and then go up to San Francisco to photograph a couple of cars immediately upon finishing. After all that, you would detour to Phoenix on the way back to Chicago for a Bunny layout at the Phoenix Club, which was to be completed in one day because a studio shot was waiting for you back at the office. This was all done alone—no assistants, no stylists, no hair-and-makeup person. Just do the job and get back to the office on time. It was a strange dichotomy: the magazine was making money hand over fist, yet they expected the photographers to do the work of several people, without additional compensation—especially when we were on location.

But you know, we didn't know any other way; we thought everyone worked like this. I finally convinced the management to hire *one* assistant for the Chicago studios. Then we got our own secretary, but they both had to take care of four of us, which meant they couldn't go on location since there was too much work in the studios. With this type of pace we certainly learned how to improvise because we had to bring back results. The job was often to find the location, buy thirty colorful umbrellas, buy some wardrobe, check the hair and makeup, and do the shot. The idea of calling in and asking for several more days on the shoot because it was raining was unheard of.

On top of everything else, it was part of the staffer's job to find Playmates for the centerfold layouts—something I failed to do in all the years I was associated with the magazine (I have a couple of memos somewhere reminding me of that fact). It was such a difficult thing to approach someone you had just met or had been working with for a short time and ask her to be a centerfold. Unfortunately, it was also a question that had become very abused by a number of less reputable photographers. My fellow staffer, Pompeo Posar, was terrific; I was an abject failure. The few times that I actually did ask strangers occurred after several vodka martinis in a jazz joint (which I always searched out in every city that I visited), and I usually asked the waitress, who had about as much chance of being a centerfold as I did. She usually told me to get lost, and I could then go back to concentrating on the music with a clear conscience, knowing that I had tried to find a centerfold.

I did only one centerfold layout during my four years with *Playboy*, but I did photograph a lot of Bunnies! Bunnies were used for cover photographs, story illustrations, and whatever else we could book them for within the magazine. Since we used them whenever possible, we were often presented with special problems. Remember, these were ordinary girls from all walks of life. Most of the girls were great-looking Bunnies, but not necessarily good model types. I learned to shoot around the problems. If a certain girl had terrific legs, we would use her for those situations that emphasized great legs.

During this time, I started to meet a number of freelance photographers, either at the Chicago office or while on assignment in various parts of the world. I was stunned to find out how much time they were given on single assignments. There I was in London, with three weeks to photograph everything—the opening of the London Casino, a major feature on the London sites with another staffer, and personality interviews—when I ran into Pete Turner. Turner had just finished three *months* of shooting in Scandinavia for one issue of *Holiday* magazine. I couldn't believe it—three months for one assignment!

As I met more photographers traveling with assistants, stylists, editors and other help, I began to think that maybe there was another approach to photography than *Playboy*'s.

After four years in Chicago, it was time to move on to New York City (as Carol and I had agreed upon), work for other magazines, and try to break into advertising photography. I gave two months notice (turned down the corner office and a small raise), and talked my brother Gene (at that time an electrical sales engineer in the aerospace industry) into going into business with me as my rep and partner.

The first year in New York was an education in itself; this is a city that doesn't care who you are or what you have done elsewhere. You have to pay your dues and prove your worth in the "Big Apple!" But we were too naive about the advertising photography business to worry about that type of thing and just jumped in—feet first. And while it did take a while for us to really break into advertising, I was able to start working for magazines immediately.

We did learn to play down my *Playboy* background with most potential clients; they usually associated the magazine solely with centerfolds and seldom recognized the other photographic content. However, my background did work positively with some clients. I started to receive a lot of calls for magazine covers, lingerie shots, mens' fashion, and other jobs that related to my work, which reflected the style of photography that *Playboy* was setting at the time. Today, even though I continue to work in several different areas, it was a natural progression for me to move in the direction of beauty and glamour. At this point, it probably represents a little over 50-percent of my work.

As crazy as my *Playboy* period was, the learning experience that it provided was invaluable. I wasn't educated in the New York City school of photography, where everything is controlled within a studio framework or you work on location with a crew of five or six people assisting you. I may often work that way now, but I learned the basics on my own. And I learned to relate to the women I was photographing on a one-to-one basis. In the end, I think that is how I formed the basis of my style.

Actually, there's not much to distinguish one beauty photographer from another. If you go through most of the women's magazines, it is difficult to pick out a singular photographer's work. We all use the same models, set stylists, and hair-and-makeup stylists. Most of the time the client isn't looking for your style in a beauty head shot as much as he or she is looking for beautiful, clean lighting—well-executed and well-exposed. If you are selling eye shadow, they want to see it. It's the same with lipstick, and any other product that appears in advertisements or magazines directed toward women. Editorially, you can experiment with a new lighting technique, or play around with the makeup. In advertising, you can not, but you can sometimes apply what you've learned through your own experimentation.

Your style in beauty photography is the result of the manner in which you work with both the models and the support team, and the results you can draw from them as a group. Pulling together the right team is the most essential contribution you make to the shoot, but in the end you are also solely responsible for the result. If it isn't there on the chrome, there's not an excuse in the world that will cover you.

Over the years I've photographed a lot of women—the short ones, the chubby ones, the shy ones, and the flamboyant ones—and I've loved every one of them. Not all of the women you will see in this book are professional models, many of them are like the women you see every day. But I see them all as being beautiful, and to me, that is the most important technique of photographing women—beautifully. ▪

CAMERAS AND
LIGHTING EQUIPMENT

From a technical standpoint, the equipment I use is the same as most professionals with large studios. My cameras of choice are primarily Nikons, and I occasionally use a Hasselblad. My use of the 2¼″-square format is usually dictated by clients, who prefer the larger transparency size. This is often true of clients from outside of New York City, who I think are too influenced by their engravers (but that's another story). Personally, I feel that I can work more intimately with the 35mm format; I can move easily, change lenses faster, and feel closer to my subject. With the longer rolls of 35mm film, I can get something going before I have to break the momentum to reload or change camera bodies. When I use 2¼″-square film, it seems that just as things start happening, I run out of film.

With the 2¼″-square Hasselblad, I use the 150mm lens for all above-the-waist photographs. For the 35mm Nikons, I carry the usual array of lenses. For beauty and head shots I use an 85mm lens and a 180mm lens, supplemented by a 105mm macro for tight shots. The 180mm lens is a wonderful tool for the beauty photographer; at $f/2.8$ it is fast enough for the slower Kodachrome 25 that I prefer and its weight is tolerable. It focuses down for a very tight head shot which means it also can be considered a studio lens. The ability to control a busy background with the use of a fast, long lens is most important for me. Professionals probably use selective focus to a much greater advantage than the average amateur.

I carry one additional lens for the 35mm that is probably different from what most photographers use—a 500mm mirror lens. The mirror lens has been around for a long time, but I bought the Nikkor 500mm in the late Sixties when it was finally manufactured with a fixed aperture of $f/5$. This made it more useful for me because I primarily work with Kodachrome 25 and need all the aperture I can get. Nikon has discontinued this lens in favor of an $f/8$ aperture, but I still use the same $f/5$ even though it has a few drawbacks. It is a very large lens and the focus is extremely critical. There isn't any depth of field and you shouldn't use it at less than 1/60 sec. You also need a very large tripod. In spite of all that I still carry it all over the world and have been rewarded many times over with a super shot. I love the way the lens can take a busy, distracting background and turn it into a tapestry. It will also flatten the contrasty light of bright sun. In addition, it's a very useful tool for photographing people because you can't focus closer than fifty feet. I have found this to be to my advantage many times when working with some models who get off into a little world of their own. By working at such a distance, you can let them do their thing without the interruption of the camera and the crew.

The light sources I use depend on the location and the effect I want to create. In the studio, I use a 4 × 4-foot (1.21 × 1.21 m) custom bank light, designed to carry five Speedotron, or comparable make, heads. I can power each head with a 2400-watt-second unit, if necessary, but when working with 35mm, I use four heads, powered by one 1200-watt-second unit. This gives me the recycle time of 1.2 seconds on fast recycle, which I prefer for beauty shoots, because it gives me the freedom to concentrate on my subject and not on the time lapse. I will also use another 1200-watt-second unit as a hair light, a background light in some instances, and an accent light, depending on the effect I'm after.

Many times, another head is added opposite the 4 × 4-foot bank light and fired through a translucent white umbrella at 400-watt-seconds to provide a very slight fill and an additional highlight in the eye. This setup allows me to photograph at $f/5.6$ or $f/8$ with Kodachrome 25.

If I am using the 2¼″-square Hasselblad, the 1200-watt-second unit on the bank light is changed to a 2400-watt-second unit to allow for the additional f-stop. Even though the 120 Ektachrome (at ISO 64) is faster, I need the additional depth of field with the 150mm lens on the camera.

I frequently use strobe on location, and will carry one 1200-watt-second and two 800-watt-second units. Many times the 800-watt-second units are sufficient because at slow recycle they are still very fast but do not draw as much amperage. Then I can work at a normal pace without worrying about blowing any circuits.

Imagine a dozen people standing around waiting for you while the assistant frantically looks for a hidden circuit-breaker panel. For this reason all of the mechanical aspects of a shoot are checked out ahead of time, including which wall outlets are on separate circuits so we can change instantly if a line goes out without trying to find the building engineer or superintendent.

I recently photographed architect I.M. Pei in his office for an international *Newsweek* cover. We were going to have ten minutes with him, in between meetings and his catching a plane for Europe. My assistant had checked out the different circuits when we were setting up and testing the lighting. Half-way through the first roll of film, we tripped the circuit, but were able to switch to another line and had power back within a minute. Many of the makeover projects I have shot are taken in hotel conference rooms, with three or four hair-and-makeup people. When they all plug in their rollers, curling irons, and hair dryers, and then we plug in the strobes . . . well, needless to say, I can't stress enough the need for planning ahead.

When working with strobe on location, I will carry a number of umbrellas. The umbrellas are used to diffuse and spread the light evenly. My standard assortment includes an opaque white umbrella and an opaque silver umbrella, which are used for bouncing the light. I also carry two umbrellas with different densities of translucence so that the strobes can be shot through them. In fact, the same densities are often carried in a smaller diameter for tight spots.

With a natural light situation, either inside or outside, I pack the same umbrellas, along with the large circular reflectors that are white on one side and gold on the other, a couple of 200-watt-second portable strobes, and a white bedsheet. I will also bring a selection of filters: an 81A warm-up filter, Polarizers, and a soft-focus filter, as well as warm-up gels for the strobes.

I should mention here that the soft-focus filter referred to is one Pompeo Posar, with whom I worked at *Playboy*, sent me around ten years ago. It is a piece of black panty hose mounted in a filter-retaining ring. Pompeo experimented with dozens of fabrics until he settled on this one type. It softens the image without losing sharpness or causing flaring. This is the one piece of equipment that I do not loan out. I've had several of them, but over the years they were lost or punctured, and I'm down to the last one. I have tried all the glass filters available, but have yet to find one that does a better job than this.

I have saved the indispensable equipment for last: my Polaroids (thank heavens for Dr. Land!). I carry a Polaroid back for the Nikon F3 and a Polaroid 195 camera. (The latter is no longer available, but if you can find one used, it is a bargain at twice the original cost.) I carry two Polaroids for a specific reason. We usually use the Polaroid camera for all test shots since the test prints are easier to see and read. We carry the Polaroid back adapted for the Nikon F3 by Marty Forscher for those situations when I am using a long lens or a very wide-angle lens. By using this system we can see exactly what the camera sees and also check for flares in difficult lighting set-ups. Every photographer has the same pat speech as he stands there folding the larger format Polaroids (we call them paranoids) down to show the art director or client exactly what he's getting. It's generally, "This isn't the same perspective," or "I'm getting the entire set in the camera." Using the 35mm Polaroid back takes the guessing out of the final result.

I tend to travel lighter than most of my friends, and over the years I have pared the equipment list down to eliminate excess baggage. This usually means traveling with a minimum of five to six cases—plus the camera bags. Everything that I have mentioned here is our basic equipment; the number of "goodies" increases in direct proportion to the assignment and its duration. One trip through the Mid-East required traveling with sixteen equipment cases for five weeks. The nightmare of dealing with the various customs agents and airport inspections was unavoidable because it was a major project and required a lot of strobe power.

(Incidentally, those travel and camera magazine tips about insisting on hand inspection of film never mention what to do when an Uzzi machine gun is stuck in your face by someone who doesn't speak or understand English! All of our film was X-rayed so many times we lost count, but we didn't have any problems with the results.)

As many of the photographs in this book will show, beauty and glamour photography varies from the basic-setup to the very complex. A simple shooting for Playtex bras will sometimes require an intricate lighting setup and a half-dozen support people in addition to my own staff. Two to three hours will be required for hair and makeup, fitting and refitting, Polaroid tests, and then final makeup or hair changes before a single photograph has been made. What goes into the shot in terms of equipment is all relative to the final results required. ■

Part One
BEAUTY BASICS

The basic tenet of beauty photography is to make someone look beautiful. Essentially, you use all your technical and mental expertise to capture that moment when everything comes together and your subject is projecting the image you want. It may take several hours of preparation to create that climactic moment or it may happen spontaneously. You have to be prepared to recognize the "decisive moment" and record it on film. Whether this moment is something you have created through a studio effort utilizing a large backup staff or one that has happened just between you and your subject doesn't matter; it's the end result that you will present to the public.

Beauty is the general name given to this type of professional photography, but beauty is a natural quality. Glamour, on the other hand, is a created illusion. However, I am in the business of creating illusions, so to discern between the two becomes a matter of semantics. The term glamour is probably used more often in relation to "Hollywood" or a "glamorous" star. To us it means a tight head shot for makeup or hair. Most women can be made to look glamorous but you have to have something to start with in order to call someone beautiful in the most literal sense.

Lighting is our main tool and the more a photographer understands this and studies various lighting problems the easier the job becomes. You can't hide lousy lighting with a great makeup job or by photographing a well-known personality. You should practice photographing differently shaped faces to determine how to solve problems with lighting, with various camera angles, or just by having the subject turn slightly. It's like being a professional athlete– practice makes perfect.

Most photographers develop professional relationships with a handful of models that change over the years. Some quit; or move to Europe; or marry, become a parent, and stop working altogether. As new models come along you find yourself getting excited by the new face or look. I have a tendency to work with the same people for years at a time. Finally someone will say, "Don't you think she is a little old for this job," or "I see you're still using what's-her-name. I didn't know she was still working." This is a very critical business, even more so than it was ten or fifteen years ago. I used to do nearly all my own casting, but now everyone is a casting expert—the client, his wife, the account executive, even the secretary to the art director.

I don't know how many times in recent years I have said that this particular model is perfect for the job only to hear a multitude of reasons of why she isn't. Then I wind up having to work with someone who has a lazy eye, a twitch, roots that are too dark—I could go on forever. Most people do not study a face the way photographers do. When I'm seeing models for a job, I always engage them in a friendly conversation. While I'm talking I'm looking over the face very carefully for the minute flaws that may give me a problem. Also, do they laugh easily, are they hiding a crooked tooth with their restrained smile, and do they relate easily to me and/or my staff? If I can figure some of these things out ahead of time, then we can adjust for them without discovering a capped tooth that reflects light slightly warmer than the rest after the shooting! (This actually happened to me once while shooting a close-up of smiling lips. Half of one of the model's front teeth appeared slightly warmer than the real side, but it wasn't noticeable to the naked eye).

I look for many things when I am casting. However, I am not looking for the perfect face. I like reading all the ingredients while many of the casting people look only at the package. I can usually work with anyone, regardless of her temperament. But it's easier working with someone to whom you can relate and know that she feels the same about you.

STYLING CINDERELLA— THE MAKEOVER

*B*eauty makeovers are a very large part of the beauty photographer's business. These photographs will show not only how such popular features are photographed for women's magazines, but also how important a makeup-and-hair stylist (in this case, Leonado De Vega) is in the pre-shooting stages of an assignment.

In this instance, we cheated a little by using a professional model who really doesn't need a makeover, but the procedure is still the same. (Actually, I cheated a little further—the model shown here is my daughter, Shannon, who has recently returned home after modeling in Europe for four years).

Most of the time, I work with "real" people like housewives, business women, and secretaries. The majority of them have never posed for a professional photographer before. I try to make them comfortable, let them relax and enjoy the session, and ask the makeup stylist a million questions! They are there for a reason, and they make notes, and have the stylist put sample colors on a piece of white paper with the name of the product used next to it.

When I am working with editors on a particular story, they ordinarily have a point in mind. They have worked the concept out with the makeup and hair people in advance, using photographs of the subject. If this is not the case, I will sit down with the stylists and discuss what the final results should be. We usually reach a mutual agreement, based upon what our client needs. I also stress to the "patient" that she should disagree if we suggest anything that she is uncomfortable with—such as an orange Mohawk hairdo!

Although most of the women who come to a makeover are willing to try a new look, getting someone to change a style she is comfortable with can be a problem. I never cease to be amazed at how many women wear their hair in a particular way or don't use any eyeliner because of their husband or their boyfriend.

I remember shooting a makeover series with Karlys Daly Brown, the beauty editor of *Woman's Day*. The subject was a thirty-plus housewife who was going through a trauma trying to decide whether or not to let us cut her waist-length hair. She kept saying that her husband would kill her; he liked her hair the length it was when they first met—when she was a cheerleader in high school! The woman hated the length at this point in her life, especially because of the care that it required. Karlys told the woman to ask her husband if he would like to take care of it. She finally decided to cut the length, but we went just below the shoulder line so it wouldn't be too much of a shock. She came back to the studio the next day and asked us to cut it even shorter—her husband loved the new look!

Shannon arrives at the studio with freshly shampooed hair, and a clean face with no makeup.

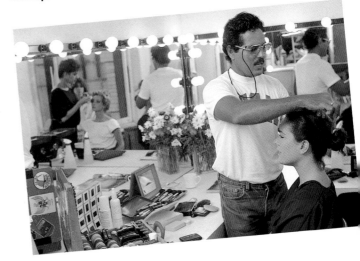

Her "party lines" are blocked out with white makeup. The white is also placed in areas where highlights are necessary; for example, under the lips to give them a three-dimensional line. It is also used to minimize the laugh lines, and down the nose for a straighter, sharper, more photogenic look.

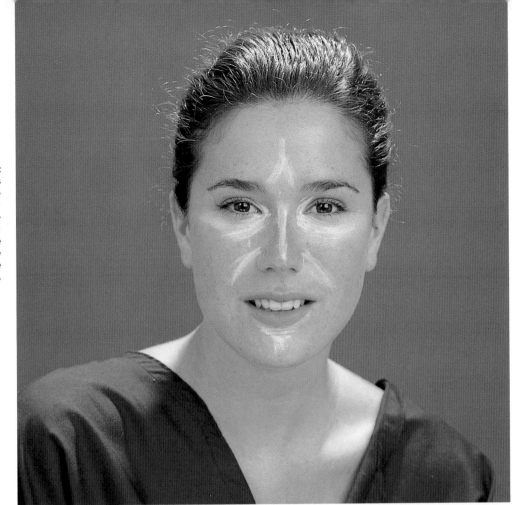

A base that has been tested for her correct color is applied over the white highlight and blended. This creates an even coloring on the skin and also eliminates most or all of the freckles and minor skin imperfections. The base is applied down the neck until there isn't any finish line, tapering off as it reaches the collar bone.

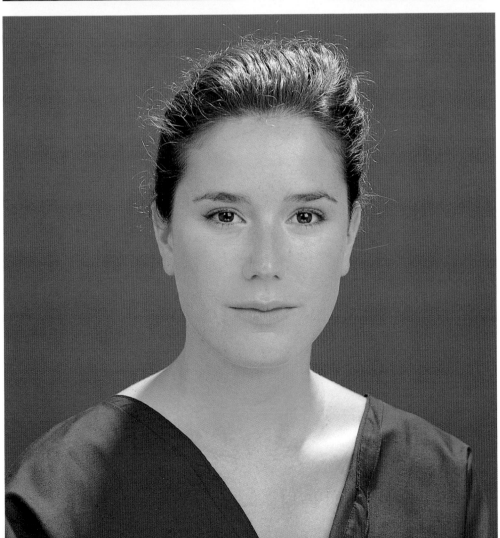

Her face is shaded with a warm brown color for added dimension and to sculpture the face by bringing out the cheekbones. This color is also added to the sides of the forehead, under the lips, and the corners of the eyes. This is indicated with lines, which are blended to accentuate bone structure and add a warm, natural feeling to the face.

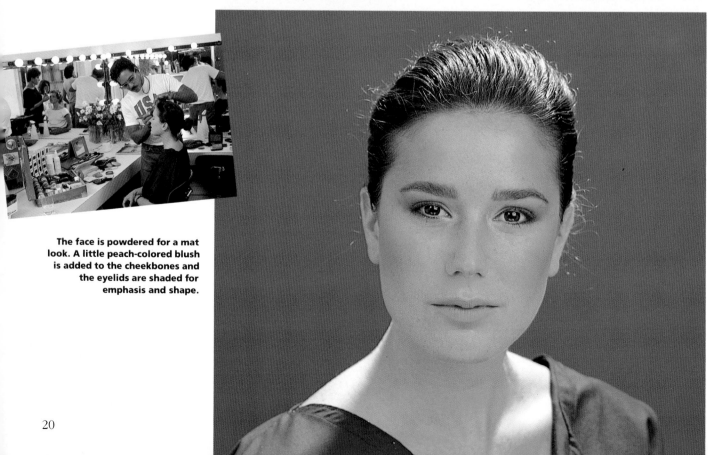

The face is powdered for a mat look. A little peach-colored blush is added to the cheekbones and the eyelids are shaded for emphasis and shape.

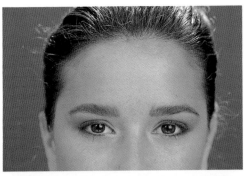

The eyebrows are filled in very softly and naturally, and extended slightly. The eyes are lined on the top and bottom corners for a better shape and look. The lips are lined correctly with a pencil corresponding in color to the lipstick to be used.

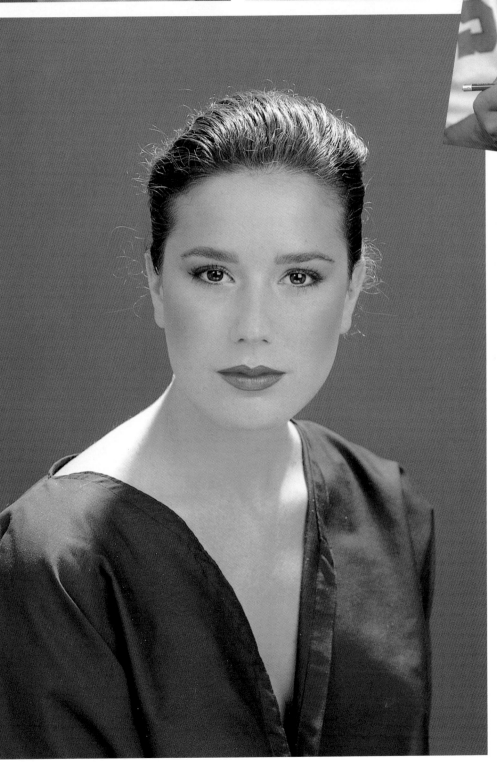

The face is powdered slightly, and lipstick is applied and blotted for excess. At this point, a little lip gloss is sometimes added for highlight. Mascara is applied evenly, and any chunks that have gathered on the lashes are combed out. A little touch of darker powder is added at the end of the eyes on the top and bottom corners for more drama. The face is now finished and checked by the photographer to see if any corrections are needed.

After the hair is styled, the makeup is checked one last time before the model goes on the set. Here, she is placed in front of a very subtle background.

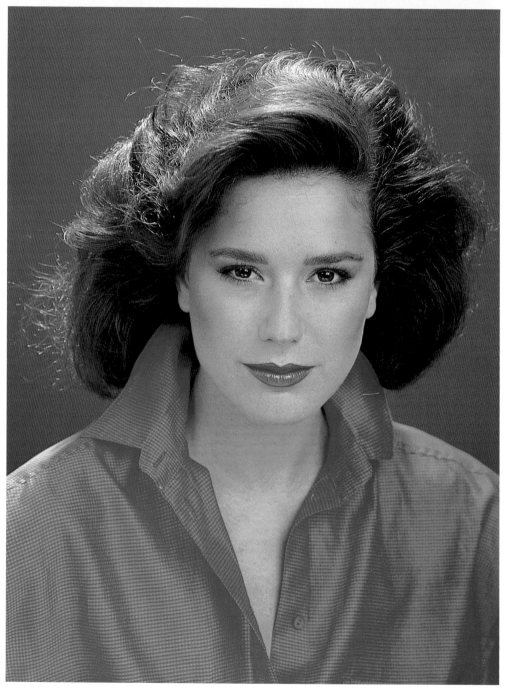

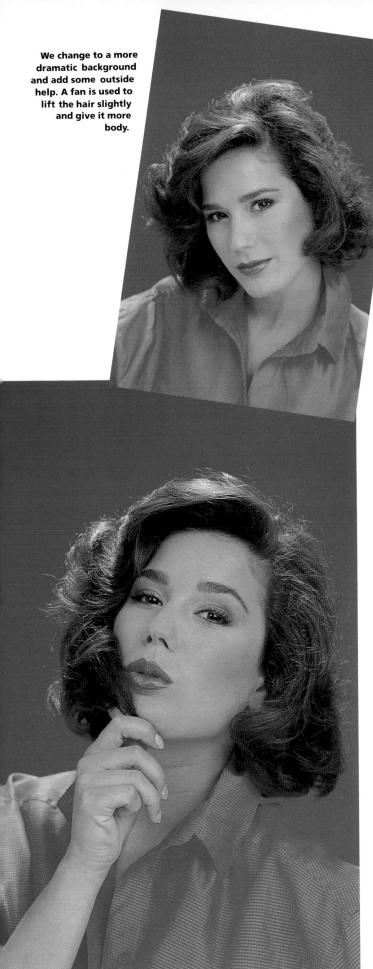

We change to a more dramatic background and add some outside help. A fan is used to lift the hair slightly and give it more body.

Models and celebrities are a slightly different case, but both usually have a particular look that they are most comfortable with. Models will accept any kind of appearance for a specific shot, as long as you don't cut their hair, or do something that they can't immediately wash out after the shoot. Celebrities are far more concerned with maintaining the look that they have nurtured over the years. Most insist on bringing their own makeup-and-hair stylist to a shoot, and some insist on a specific photographer. These requests are granted by the client in direct proportion to the size of the orbit the star happens to be in during that moment in her career. If I am the photographer of choice, I find it best not to fight their preference of stylist. A satisfied, happy subject is a lot easier to deal with than one whose ego has been slightly trampled upon.

But even when this decision is left to the photographer, the selection of a makeup-and-hair stylist becomes a very important factor in all beauty sessions. Most photographers have a group of people they choose from, depending on the requirements of the job and the availability of the stylist. These working relationships are usually developed over a period of years, with a lot of trial-and-error in between. Some photographers insist on only working with one person. Unfortunately, this often leads to the same look in all their photographs. Thankfully, there are a number of excellent stylists in New York, and the only problem I've ever had is when I've used someone who is primarily a television makeup artist. For their own medium, they're fine, but transposed into the print medium, where one frame is scrutinized as the final result, the heavy use of flat pancake makeup becomes dull and one-dimensional.

Under normal conditions (and with a normal client), I prefer to let the makeup-and-hair stylist suggest a direction based on the model we are working with and the parameters of the job. I also use stylists who are not going to get bent out of shape if the client or account executive makes a suggestion. The end result in choosing the stylist should be to create a happy team effort, because there's nothing worse than a reshoot—unless it's in the Caribbean! ∎

In the final shot, we allow Shannon a little more freedom of expression.

LIGHTING THE FACE

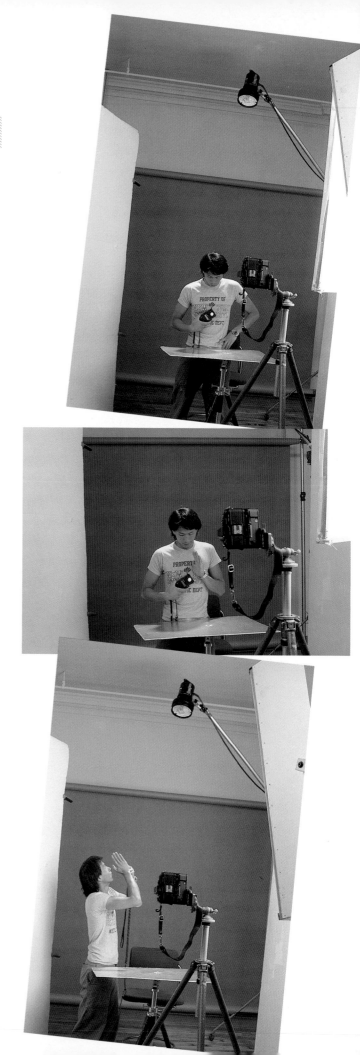

The proper lighting goes along with the right makeup, and in photographing people lighting becomes your most important tool. In fact, this is even more true in people photography than in product shots, because you don't always have the advantage of a design element to help carry the shot. You're dealing with the human element; maybe one eye is slightly larger than the other, or the person has a square jaw, or a button on the end of the nose. You have to constantly work with the given facial structure in order to make all the features come together in the final photograph as a pleasing whole. Lighting, makeup, slight changes in the position of the head, and a lot of experience on the photographer's part in studying faces and bone structure all work together.

It is difficult to point out specific techniques, such as raising the chin a half-inch to appear to shorten the nose in a photograph. This is just one of the hundreds of things that I have noticed after years of observing faces through my lens. But each face is different, and I don't think about these things as I'm doing them; they happen while I'm watching my subject.

There are a number of misconceptions promoted about lighting the face for photography. In my opinion, the worst approach to teaching the intricacies of photography is to set up rules of lighting, composition, and design. We have enough rules to contend with on the technical end. The creative side—and I consider lighting to be a creative element—should be free of parameters.

When you are photographing a face with full beauty lighting and the client has selected a model with full cheeks or a square jaw, there is very little you can do— other than be sure the makeup stylist knows his stuff. If they've hired you because they want a full beauty light with just a slight direction, you can't cast a heavy shadow to hide something.

My best advice in regard to lighting is to study the effects of light on people. You should do this constantly—when you are at a dinner party, at the beach, in a restaurant— wherever you may be. Sometimes a job comes along that requires special lighting and while I'm thinking about it, I always seem to use something that I have seen somewhere and tucked away as a possible solution. You really have to be a diligent student of lighting, no matter how long you've been taking photographs.

The background shots shown here were taken during the makeover session with Shannon. They illustrate many of the procedures that were used in the photographs on the following pages and show my assistant, Ray Chin, taking a series of meter readings to balance the lighting according to my preferences for the job at hand.

He reads the overall light first, and then takes separate readings for the hair light, the main light, and the fill light. Although we have lighting setups that are basic for particular needs, I do not have any set formulas. We add or subtract from these basic setups, and experiment with new ones all the time.

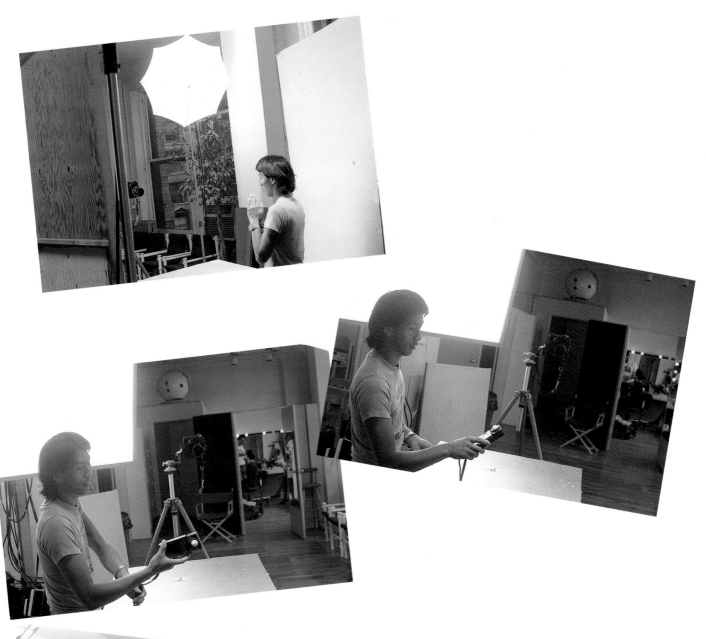

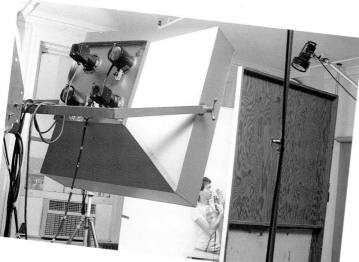

After these initial readings, we discuss the results and make additional changes in watt-seconds before we make the first Polaroid test. I work under the premise that bracketing is unnecessary and demand rigid control of meter reading—something that seems to be lacking in many photography schools these days. This is unfortunate because it dilutes the technical expertise that should be developed as a photographer grows. If nothing else, when an assistant leaves my studio, he understands the nuances of exposure readings; the most I will bracket in almost all instances is one half-stop down from the reading, since I tend to go for full saturation.

You'll notice in this instance that we did not stray from the original lighting setup in any of the shots. This is important with makeovers, otherwise you are not being fair to the magazine readers. Many times we'll add a more dramatic background (as we did here) to heighten the effect of the final results, but the lighting of the subject should be the same in both the before and after shots. ∎

SIMPLE
STUDIO LIGHTING

This series of photographs of model Belinda Johnson demonstrates the simplest lighting setup that I use in the studio. The bank light is placed directly in front of the model, over the camera, using four heads with a total of 1200-watt-seconds of power. The placement of the bank light will vary according to the result I wish to produce. It is usually placed 6-to-8 feet (1.82 to 2.43 m) away from the model. A 200-watt-second hair light with a 2-inch (5.08 cm) snoot is placed on a boom about 4-to-6 feet (1.21 to 1.82 m) above and slightly behind the model. Keep in mind that the angle of the hair light should be carefully adjusted so it does not spill over the head and add a distracting highlight on the end of the nose, or on the forehead or cheeks. In some instances, you may not even want it hitting the shoulders.

Two 4 × 8-foot (1.21 × 2.43 m) white rolling flats were placed on either side of the model to bounce light back onto the sides of the face and to keep out any extraneous light or reflective colors. A soft, dull-silver, 2 × 3-foot (.60 × .91 m) foam-core reflector is mounted on a tripod and placed directly under her face, approximately one foot below her chin. The angle of the reflector can be changed to create different intensities of fill. In this situation, the reflector was perfectly level with the floor to completely fill the shadows under the eyes, nose, and chin, to create an additional soft reflection in the lower half of the eye. ■

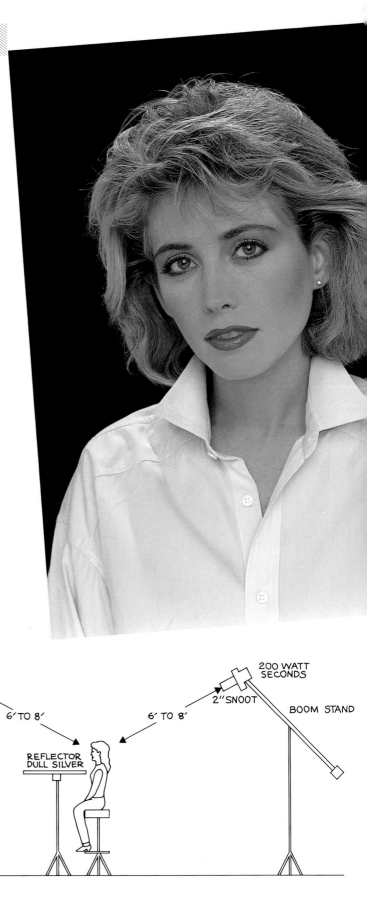

1200 WATT SECONDS

200 WATT SECONDS

2" SNOOT

BOOM STAND

6' TO 8'

6' TO 8'

CAMERA

REFLECTOR DULL SILVER

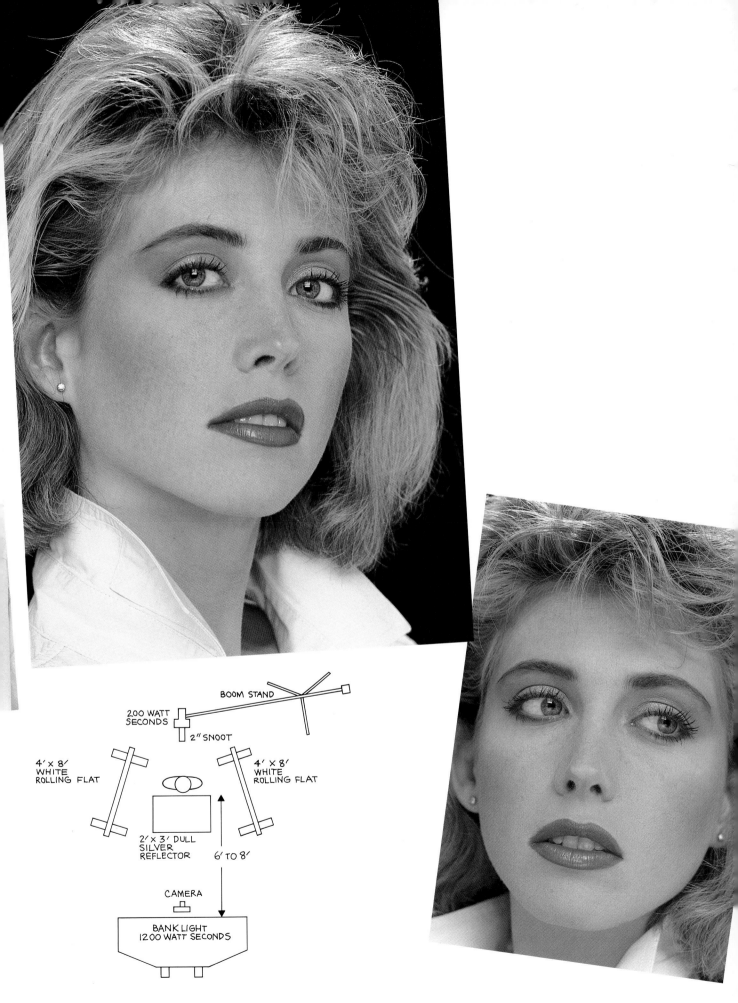

BOOM STAND

200 WATT
SECONDS

2" SNOOT

4' x 8'
WHITE
ROLLING FLAT

4' x 8'
WHITE
ROLLING FLAT

2' x 3' DULL
SILVER
REFLECTOR

6' TO 8'

CAMERA

BANK LIGHT
1200 WATT SECONDS

BRIGHT LIGHTS, MORE GLAMOUR

In this sequence, we've changed Belinda's hair and makeup and intensified the lighting to reflect the more glamorous look. The bank light was moved to the right of the camera at about a 30-degree angle. This gives direction to the lighting and adds dimension to the face. The hair light was changed from the 2-inch snoot to a focusing grid, which allows for a greater spread of light and a little hotter light. The reflector remains in the same position, but is angled approximately ten degrees toward the camera to bounce a slightly hotter reflection into the lower half of the eye. A 200-watt-second head is added, pointed toward the background. The distance here is determined by the amount of spread or intensity of background color I am after. A 400-watt-second head is placed to the left of the camera and fired through a translucent white umbrella. ■

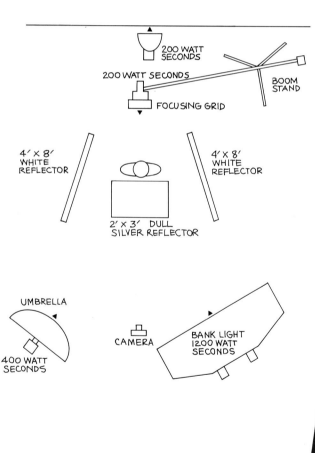

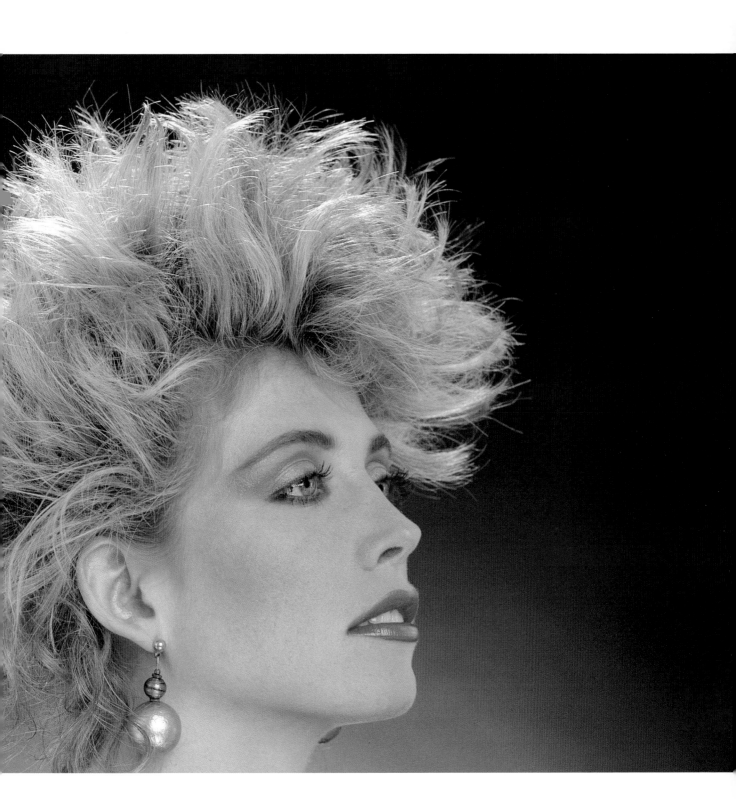

HIGHLIGHTING HAIR

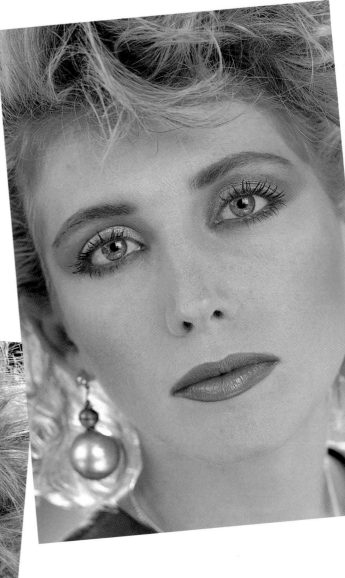

*E*verything remains the same here as the previous lighting setup, with the addition of one 200-watt-second, bare-tube head placed directly behind the model's head to totally emphasize the hair. A word of caution goes along with this setup—when working this close to a model's hair, check the condition of the tube in the head and don't use a modeling light. Models can become upset about having their hair singed! ▪

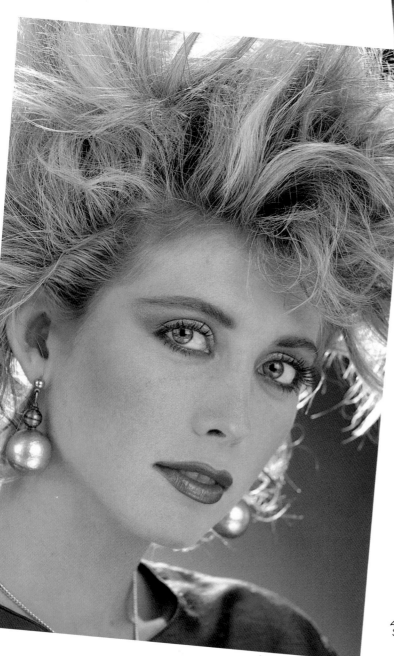

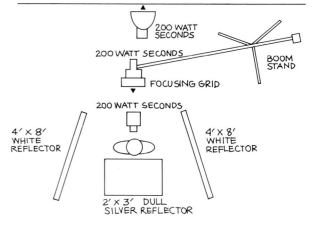

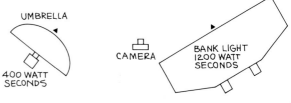

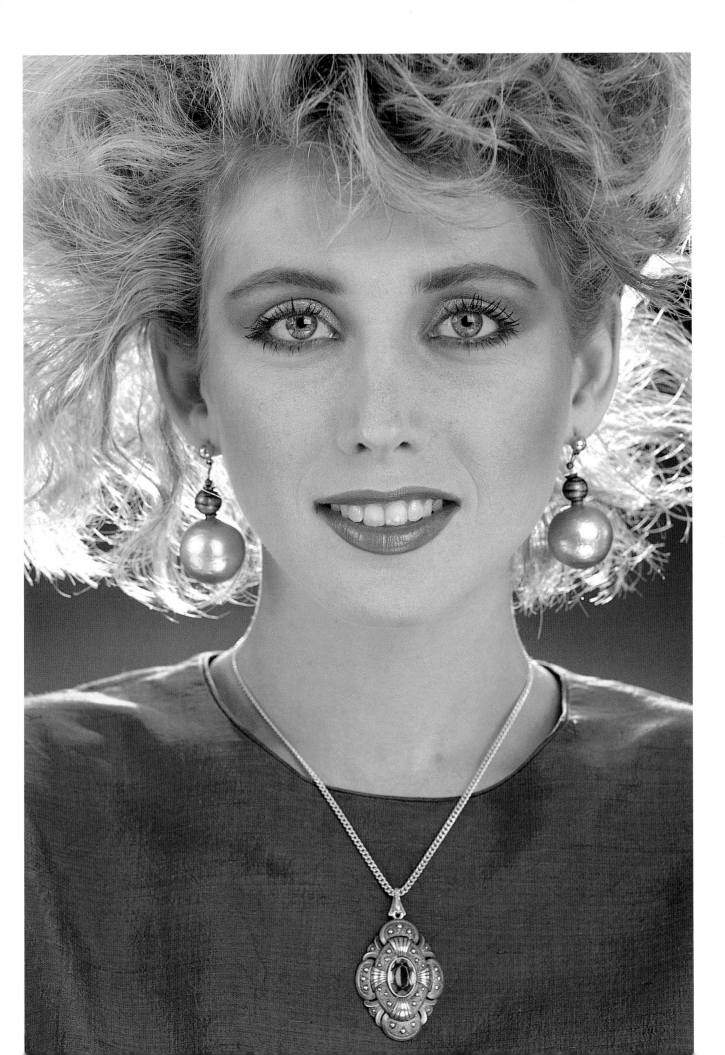

PRESERVING HER TAN

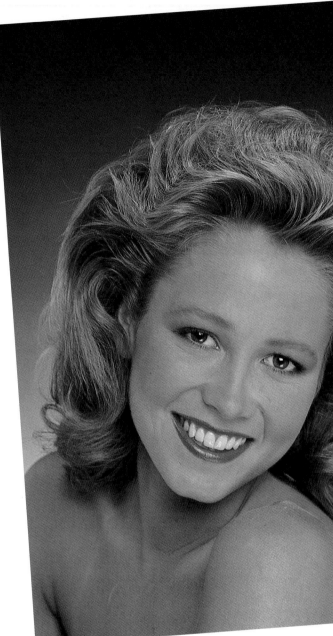

Model Sheri Montgomery has a great smile and radiates a very open and fresh look. This lighting setup is designed to highlight that appeal, and work with—not against—her tanned skin. Tans have a tendency to photograph shinier under studio lights, so extra consideration must be taken with both the makeup and the lighting setup. First I discuss the problems with the makeup stylist. I don't want to lose that healthy look to a heavy foundation, yet I don't want shine on the nose and forehead either. Then I begin to work with the lights.

The 1200-watt-second bank light is placed directly in front of the model, with a 4 × 4-foot (1.21 × 1.21 m) diffuser placed one foot in front of the bank to soften the light. This diffuser hangs in front of the bank light when I want additional softness. It is a simple frame made with a 1 × 2-inch (2.54 × 5.08 cm) wood and covered with the cheapest white bedsheet you can buy (it should be almost like cheesecloth). You lose about a half-stop of light, but it becomes very useful in situations like this. A diffuser is also placed in front of the hair light. While the diffusion serves to soften the shine on the skin, the shiny silver side of the reflector—placed in front of the model and angled 10 degrees toward the camera—is used to bounce more light onto the face, adding luminescence and preventing the skin from looking flat.

It may seem strange to cut down the shine on the face from the strobe with the diffuser and then add a shiny silver bounce, but the strobe would give me a distinct reflection on the skin around the forehead and nose. By diffusing and using a silver bounce I can get rid of these hot reflections. The length of the bounce gives me a broad spread of light across the entire face and causes the hotter reflection in the eyes and teeth, but this all goes with Sheri's smile.

Finally, a deep-blue gel is added to the background light to turn the dark gray seamless paper into tones of blue. You can see the difference in the two photographs shown. ■

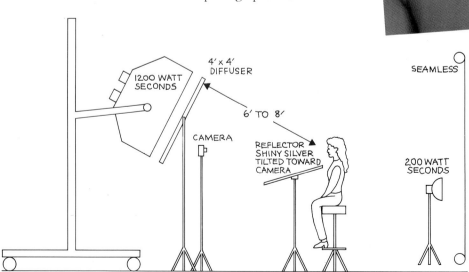

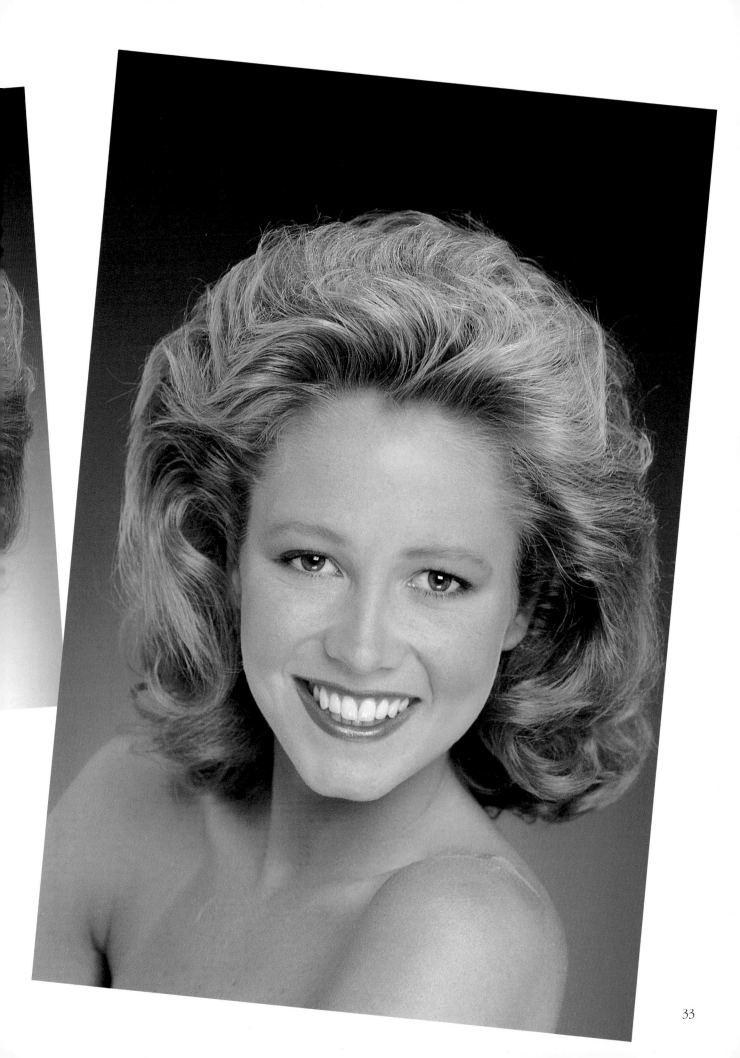

LIGHTING OPTIONS

*T*obi Bruce is a California "golden girl," blonde and blue-eyed, with a wonderful open face. In order to achieve a rich, but flat, light, I used the available light from the studio's windows as a large bank light, and supplemented the available light with strobes. Three heads were arranged in a triangle around the camera position—one above the camera on a boom stand, one on the right, and one on the left. The lights were fired at the same watt-second strength and each was fired through a translucent umbrella. ■

In the photograph below, I used a white reflector for fill and a shutter speed of 1/30th sec., whereas in the photograph on the opposite page, top, I changed to 1/8th sec. to use the available light as fill and slightly shift the color balance. For the photograph of Tobi on the opposite page, bottom, we turned off the strobes, and let the sunlight filter through a cheese-cloth scrim and bounce off a gold reflector, which was used as a background.

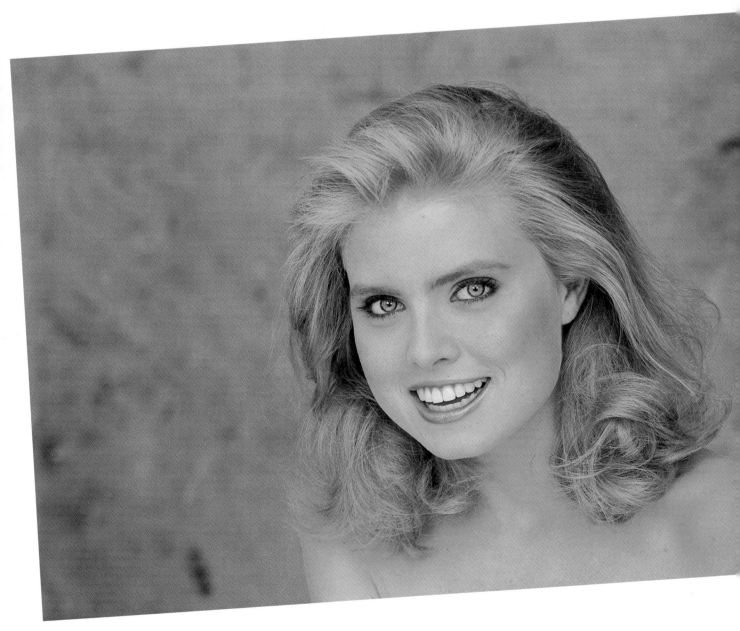

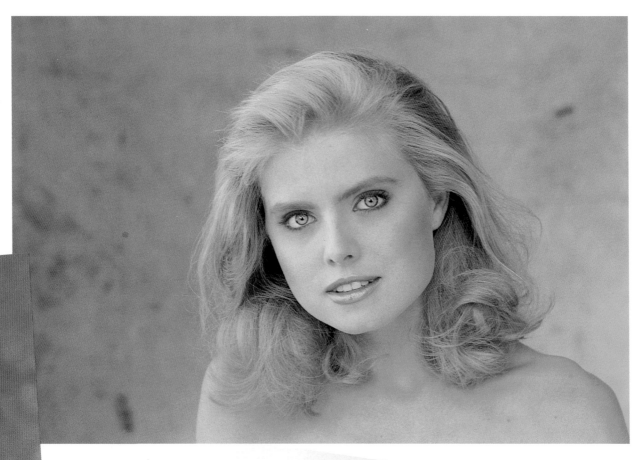

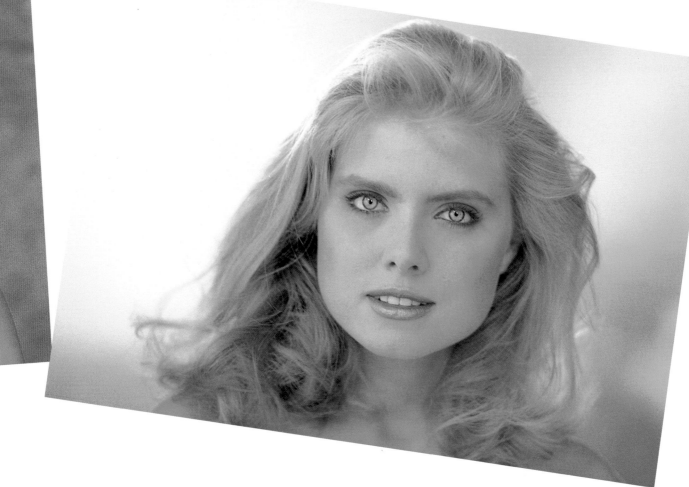

THE COLOR OF LIGHT

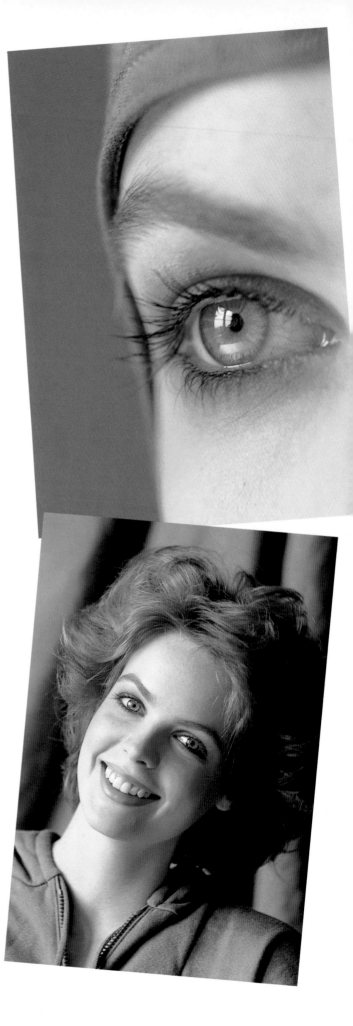

As a student of light you begin to catalog various combinations in your mind for use as starting points when you don't have a totally preconceived plan. For example if I am asked to illustrate a sunny morning, I will look for a location that faces east or south so I can control the amount of light and color coming through the windows. Mornings are generally bright and cheery and late afternoons warm and soft, but there are so many variables that a statement such as: "All late afternoon light is warm," is wrong. It depends on what part of the world you are in and how much atmospheric pollution is present.

I have worked on locations like Molokai in the Hawaiian Islands where the sun is very hot in color until approximately ten minutes before it sets. On the Atlantic coast of Morocco the sun remains white hot until it actually breaks the horizon. The closer you are to large cities and populated areas the longer you can "milk" the warm color of a late sun. All this really means is the more you work, the more you gain experience in dealing with each assignment and its needs. You constantly improve your ability to improvise.

I've recently moved into a new studio, which has an entire wall of windows facing west. I try to take advantage of the available late-afternoon light whenever I can. I've also found that the large building across the street acts as a giant reflector of the sun when it's in the east, so at different times of the day I can work with a variety of available light effects.

I don't try to filter the color at different times of the day because light changes too much depending on the general weather conditions. We can't use available light on a dark, dreary day and often light is too warm late in the day. If I schedule a shoot to take advantage of the late afternoon sun I know it will rain! Most of these available light shots happen at the end of the shoot. We often schedule something for late in the day and if the conditions are right we turn off the strobes and use the available light. If necessary we can warm up the available light with an 81A filter and gold reflectors.

This series of photographs of model Gail Ogden was taken in the late afternoon. I've used only the available light with two reflectors. A silver fill card was placed directly in front of her, and a 4 × 8-foot (1.21 × 2.43 m) white flat was positioned about three feet away from her on the shadow side for additional fill.

As with most available light shoots, we wanted to keep the setting simple, allowing the backdrop to add interest and texture to the scene. In keeping with the natural setting, makeup-and-hair stylist Leonado De Vega kept the makeup light, concentrating on Gail's eyes. The makeup here matches the color of the backdrop, which adds impact to the closeups. ■

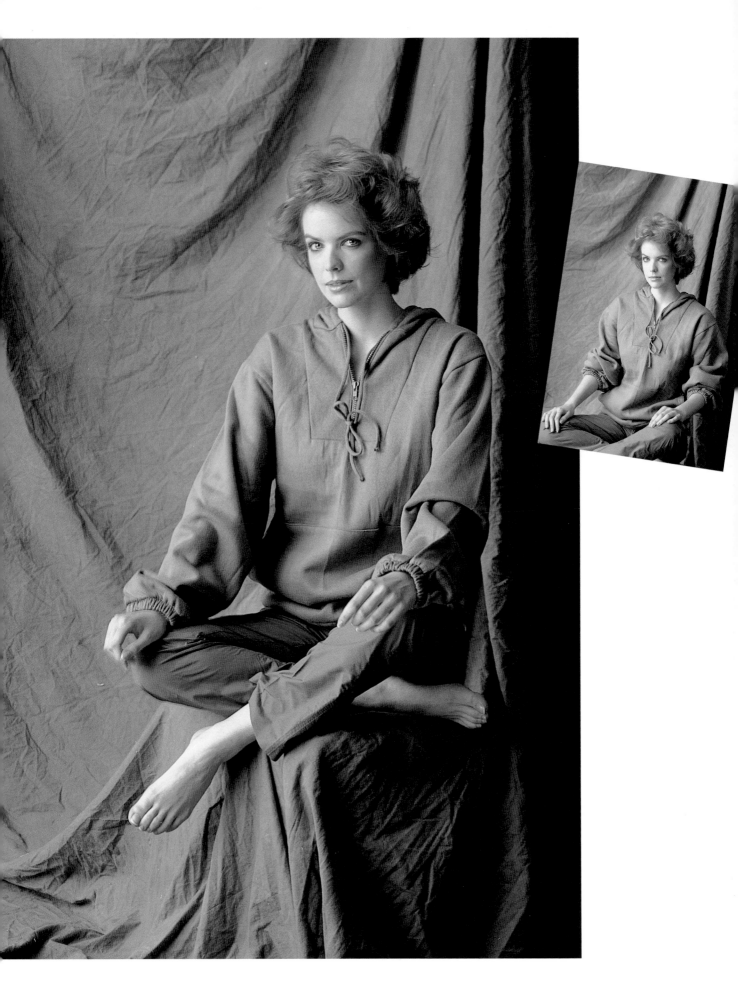

THE COLOR OF LIGHT

The quality of light achieved in a photograph also depends on the time of day that you shoot. This series of photographs will show the subtle changes that occur in just three hours of shooting on an October afternoon. We began the session at 2:00 PM, with the model facing the large bank of windows in the studio at approximately a three-quarter angle. Notice how the light is fairly even, with subtle highlights falling across her face and hair.

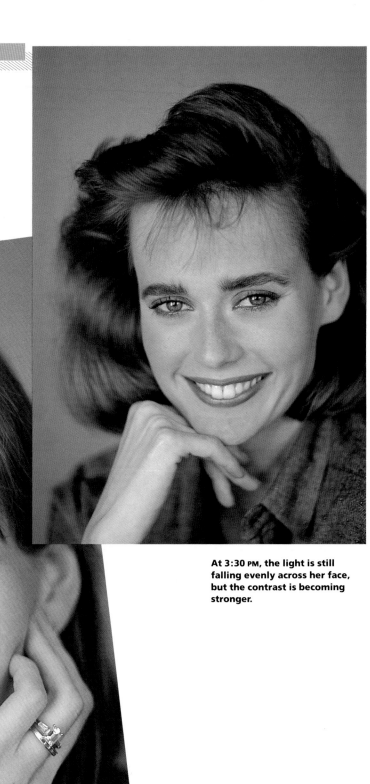

At 3:30 PM, the light is still falling evenly across her face, but the contrast is becoming stronger.

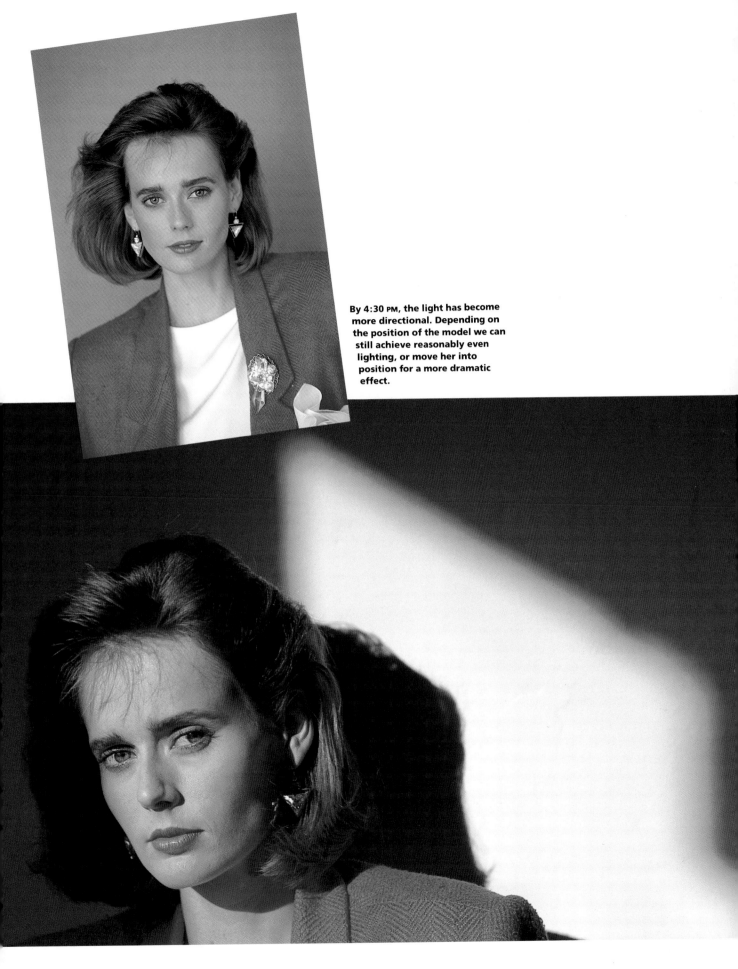

By 4:30 PM, the light has become more directional. Depending on the position of the model we can still achieve reasonably even lighting, or move her into position for a more dramatic effect.

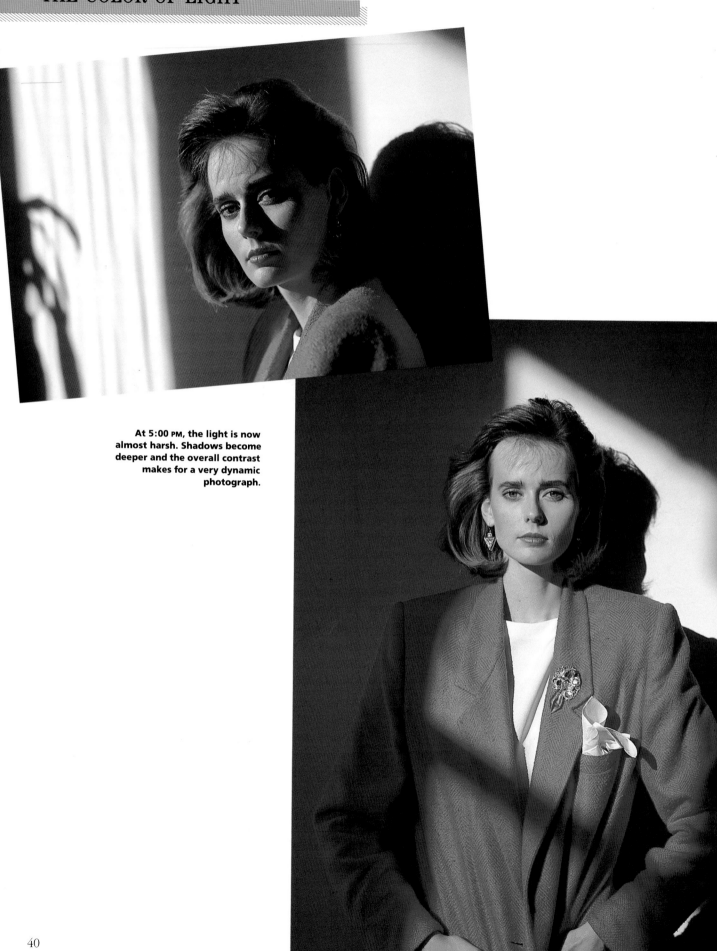

At 5:00 PM, the light is now almost harsh. Shadows become deeper and the overall contrast makes for a very dynamic photograph.

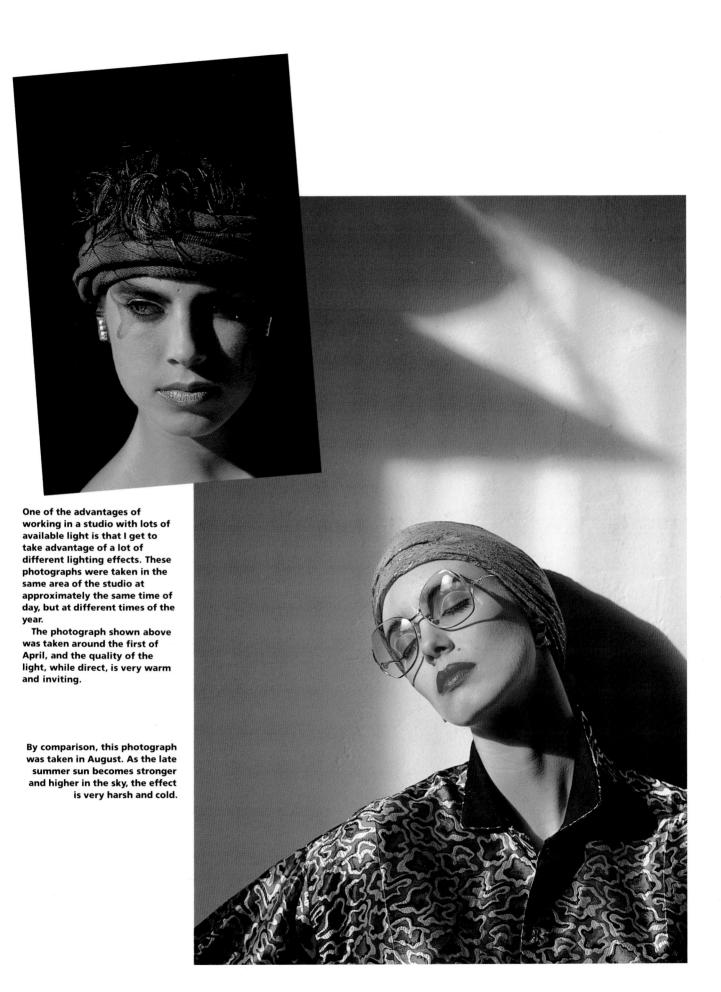

One of the advantages of working in a studio with lots of available light is that I get to take advantage of a lot of different lighting effects. These photographs were taken in the same area of the studio at approximately the same time of day, but at different times of the year.

The photograph shown above was taken around the first of April, and the quality of the light, while direct, is very warm and inviting.

By comparison, this photograph was taken in August. As the late summer sun becomes stronger and higher in the sky, the effect is very harsh and cold.

MIXING STROBE, TUNGSTEN, AND AVAILABLE LIGHT

As a professional photographer, I feel that I'm hired to solve problems for the client—photographic problems, that is. And solving these problems involves a knowledge of composition, exposure, and lighting, all working together to create the effect that the client wants.

The main reason photographers use strobe is the absolute consistency of the Kelvin degree or color of the light. Although the strobe is balanced for daylight film, we sometimes have to compensate on a particular emulsion, either to warm it up or to remove too much cyan or magenta. But as a basic tool, the strobe is very useful where daylight color can shift on you instantly with a cloud simply moving in front of the sun.

Tungsten lighting can shift color balance if the voltage drops or the bulbs being used are very old. As you can see in some of the photographs shown here there is a difference in the whites when the least amount of daylight is evident in the exposure.

I was asked by my friend Karen Gangle, who makes custom lingerie, to take some photographs of her work that she could sell from. It also gave me the opportunity to take some shots for my portfolio. We wanted photographs that were very feminine, but a little on the sexy side (after all, men do buy lingerie for their ladies). I used my 200-year-old farm house in Connecticut as the setting. This allowed us to put the model against a realistic, but romantic, background, and to mix various types of light to create different effects.

The model is Mya (that's the only name she uses), who was chosen for her exotic good looks and beautiful skin. As always, working with someone like Mya gives a photographer one less problem to worry about. ■

These two photographs were made with one 800-watt-second strobe fired through an umbrella as the primary light source. The ceiling was 7½-feet high and painted white, as were all the walls. The one strobe bounced all over the room and created a nice, even light. I used the 50mm lens and exposed for the window light at about 1/15 sec. to add some backlight to the scene and some fill for the shadows.

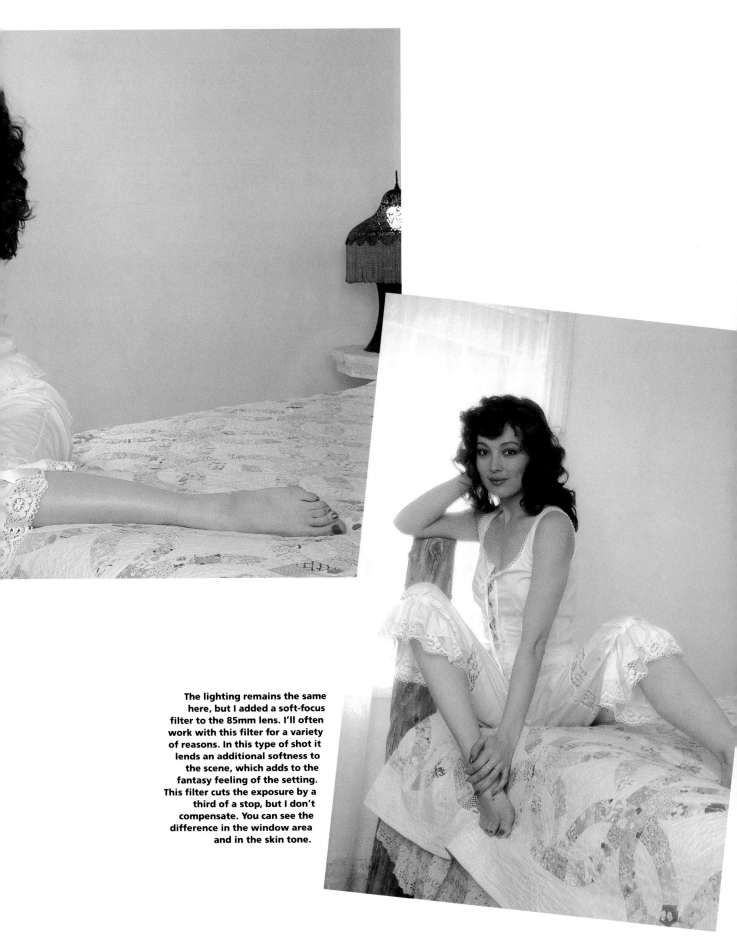

The lighting remains the same
here, but I added a soft-focus
filter to the 85mm lens. I'll often
work with this filter for a variety
of reasons. In this type of shot it
lends an additional softness to
the scene, which adds to the
fantasy feeling of the setting.
This filter cuts the exposure by a
third of a stop, but I don't
compensate. You can see the
difference in the window area
and in the skin tone.

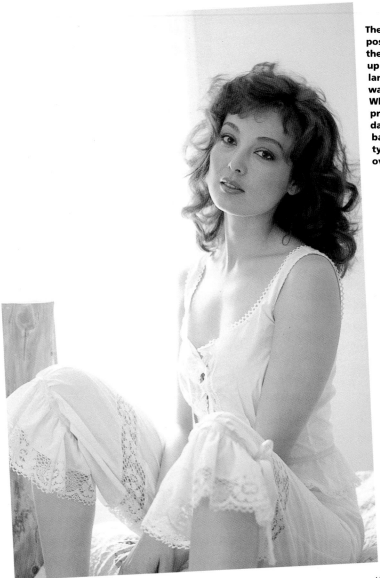

The lights remain in the same position here, but I've changed the exposure to ⅛ sec. This picks up the tungsten light of the lamp beside the bed, adding a warming effect to the scene. While the strobe is still the primary light source, the daylight and lamp light are balanced in the exposure, so one type of light does not overpower the other.

I've changed the exposure here to ¼ sec. to allow daylight to become the primary light. The strobe provides the fill and the bed lamp is a complementary light.

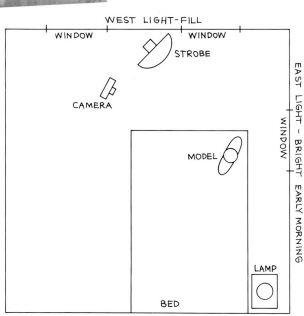

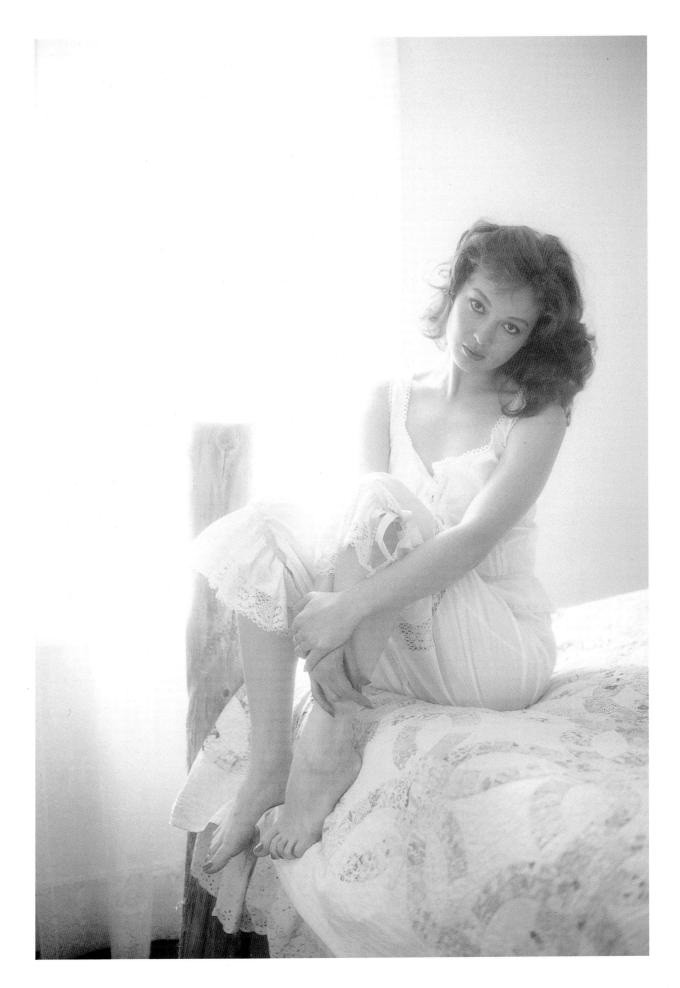

REFLECTORS

Whether working outdoors or in the studio, reflectors can provide the crucial finishing element to any lighting situation. They offer the photographer more critical control over the direction and quality of any type of light, and can be used for anything from adding a highlight to a model's eyes to providing a subtle warmth in the overall tone of the photograph.

I work with a variety of reflectors, both outdoors and in the studio. In most instances I use a neutral white reflector, or sometimes a silver one if I need a stronger fill light for the model's face. On rare occasions I use a gold reflector to add a yellow tone or additional warmth to the photograph.

The photographs shown here were taken in the studio with a basic beauty lighting setup. The only change is in the type of reflector used. In all cases the reflector is placed low in front of the model and angled toward her face to provide fill light. ■

We start with the white reflector, which provides an even, flat fill light across the model's face.

The change to a silver reflector provides a very subtle change in the photograph. The metallic finish reflects a slight sparkle in the skin tone and gives a shinier highlight in the eyes.

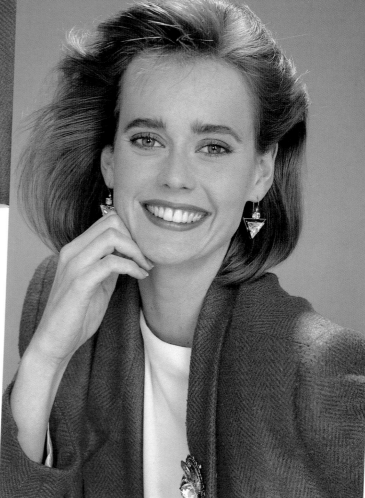

Using a gold reflector creates the most obvious difference. The overall tone of the photograph has become warmer, which is especially noticeable in the model's skin tone.

IDEAL OUTDOOR LIGHT

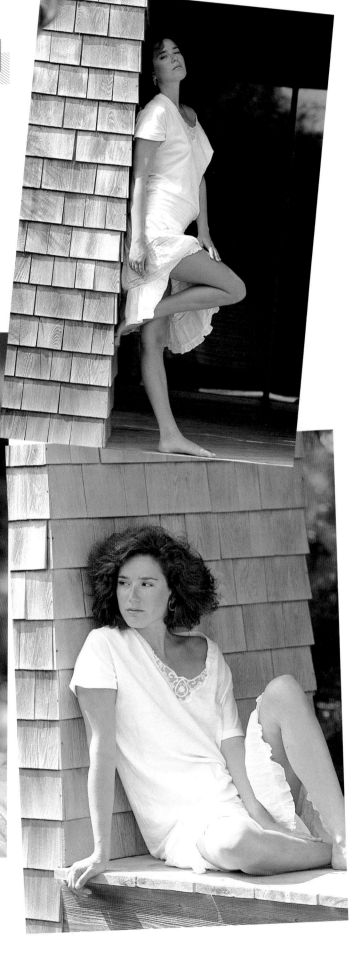

Open shade is one of the most flattering lighting situations to photograph in. It is flat and even, and you don't have to use reflectors to fill any shadow areas. Because of this, it's one of the best types of light to look for when working spontaneously.

Shannon wanted me to take some photographs for her portfolio, so we looked for an area around the house that had good lighting for some casual poses. I also liked the fact that bright sunlight dappled into the edge of the frame here.

The closeups were taken with a 180mm lens with an 81A warm-up filter. For the full-length and sitting poses, I switched to an 85mm lens, but still used the warm-up filter because open shade tends to be a little cool and I wanted warmth in the skin tones. ◼

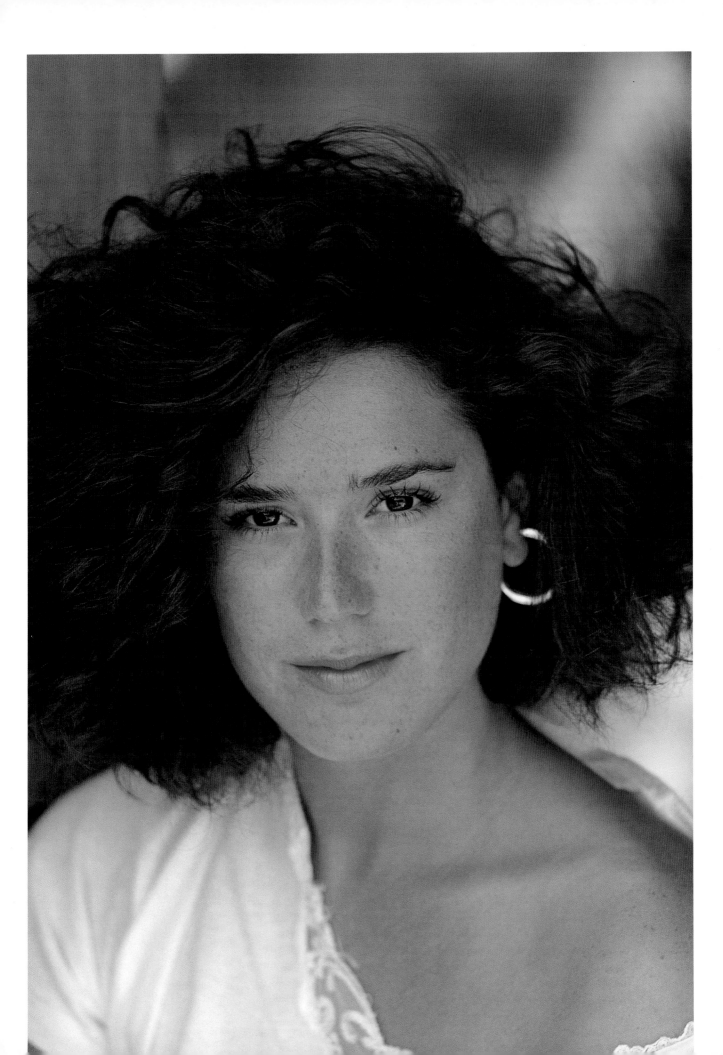

OUTDOOR LIGHTING EFFECTS

One advantage to working outdoors is the tremendous freedom you have from the encumbrances of studio lighting. You can just turn the model in the opposite direction for a different look in the lighting or the mood of the shot. However, this freedom has a price because many of the problems that could be controlled in the studio still manage to surface out of doors. The color will shift as the light changes, and you have to work to control the harsh effect of full sun. And, inevitably, you're working at the wrong time of day to capture the look that you want.

This doesn't mean that it is impossible to work outdoors. You simply have to be aware of the variables and understand how to work around them. As these photographs will demonstrate, there is a great variety of effects to be achieved. ▪

Here, Belinda simply turned around to face the sun. We filtered the sunlight through a translucent white umbrella so that it wouldn't be so harsh, and used a large white reflector to fill the shadows.

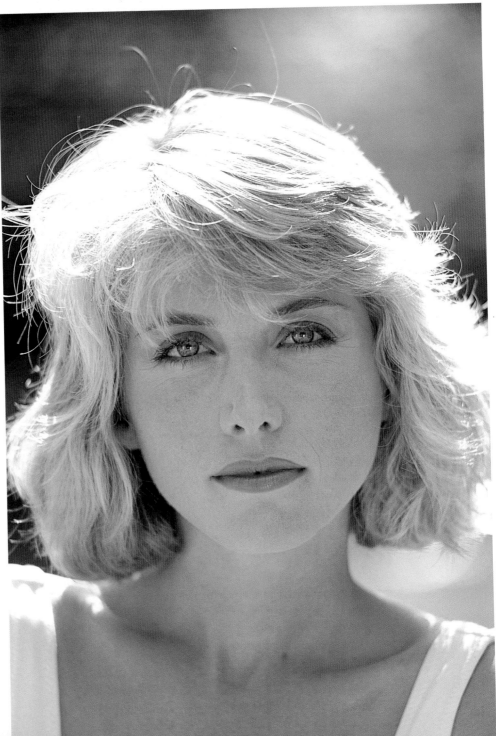

This photograph of model Belinda Johnson use strong, midday sun as a backlight. A large reflector provided extra fill and a white bed sheet was placed in front of her on the grass to bounce more light onto her face. I used a 180mm lens with an 81A warm-up filter to emphasize the golden tones of the sunlight and to give warmth to the skin tone since her face was in shade.

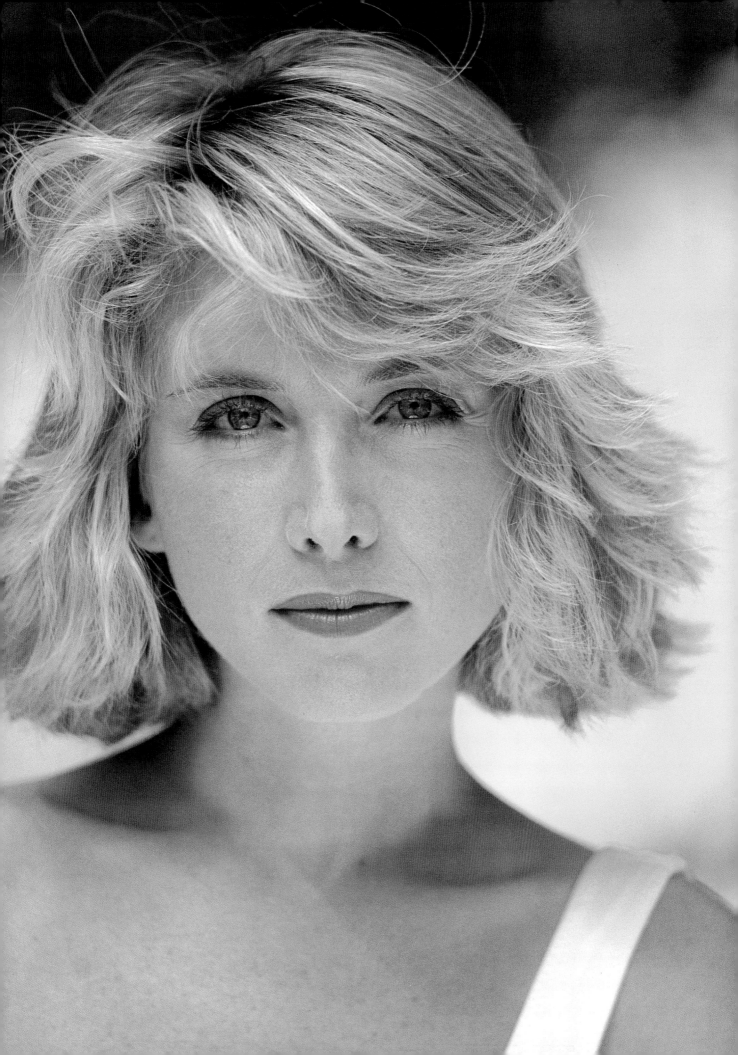

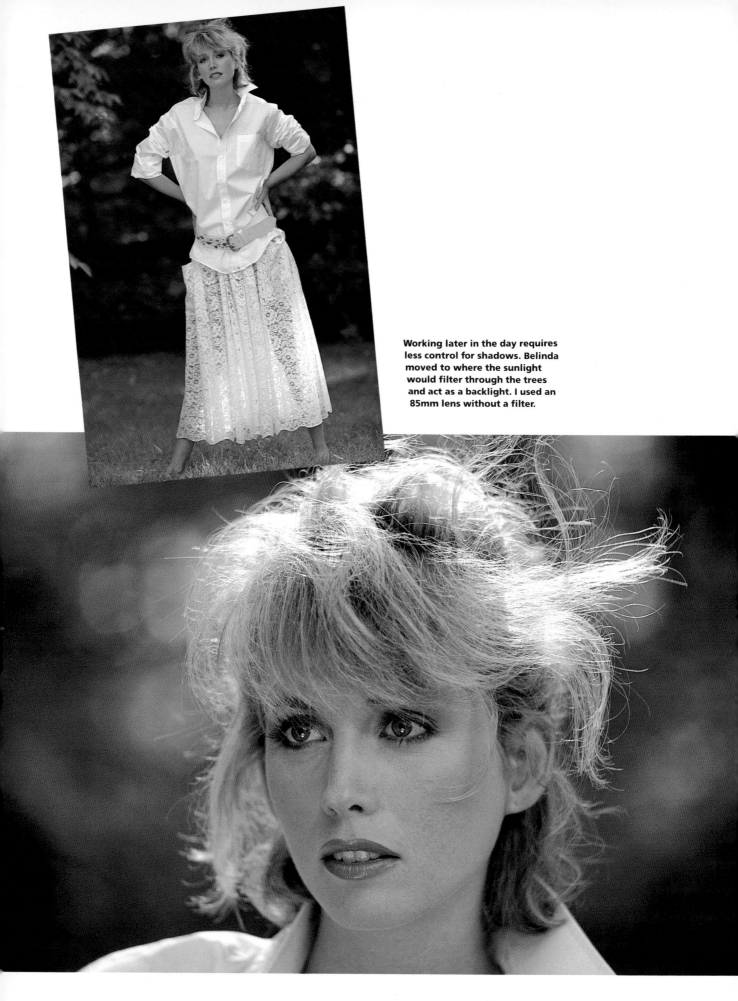

Working later in the day requires less control for shadows. Belinda moved to where the sunlight would filter through the trees and act as a backlight. I used an 85mm lens without a filter.

52

Reflectors not only help to control shadow areas, they can also be used to change the color of the reflected sunlight. These two photographs of Belinda were taken late in the afternoon. In the photograph on the left, the white side of the reflector was placed in front of her. In the photograph on the right, we switched to the gold side of the reflector. You can see the subtle warmth that this simple change adds to the scene.

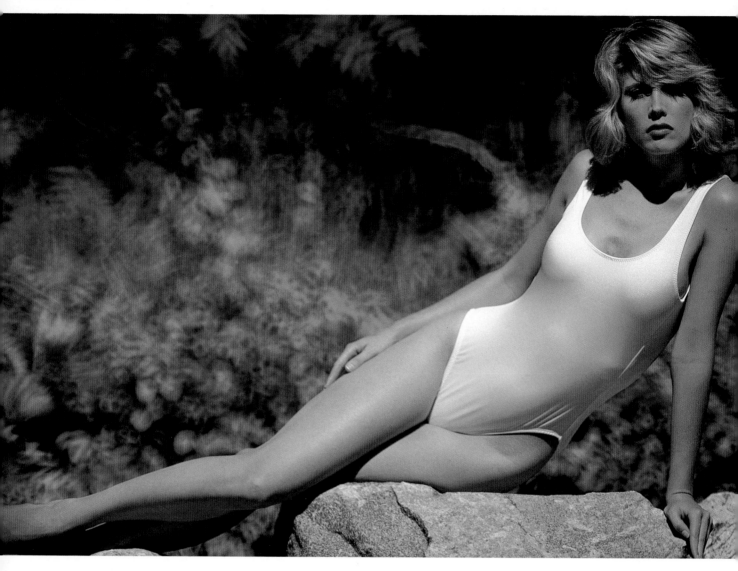

Bright sunlight adds a lot of contrast to a scene—especially if the model is wearing a white bathing suit. I keep a 500mm mirror lens with me for situations such as this, because a mirror lens tends to flatten contrast. This photograph was taken with a 500mm f/5 Nikkor lens.

In this photograph I was going strictly for the graphics of the swimsuit and the model's position on the lounge chair. I climbed up on a ladder and used my 50mm lens. A large, gold reflector was balanced against the ladder.

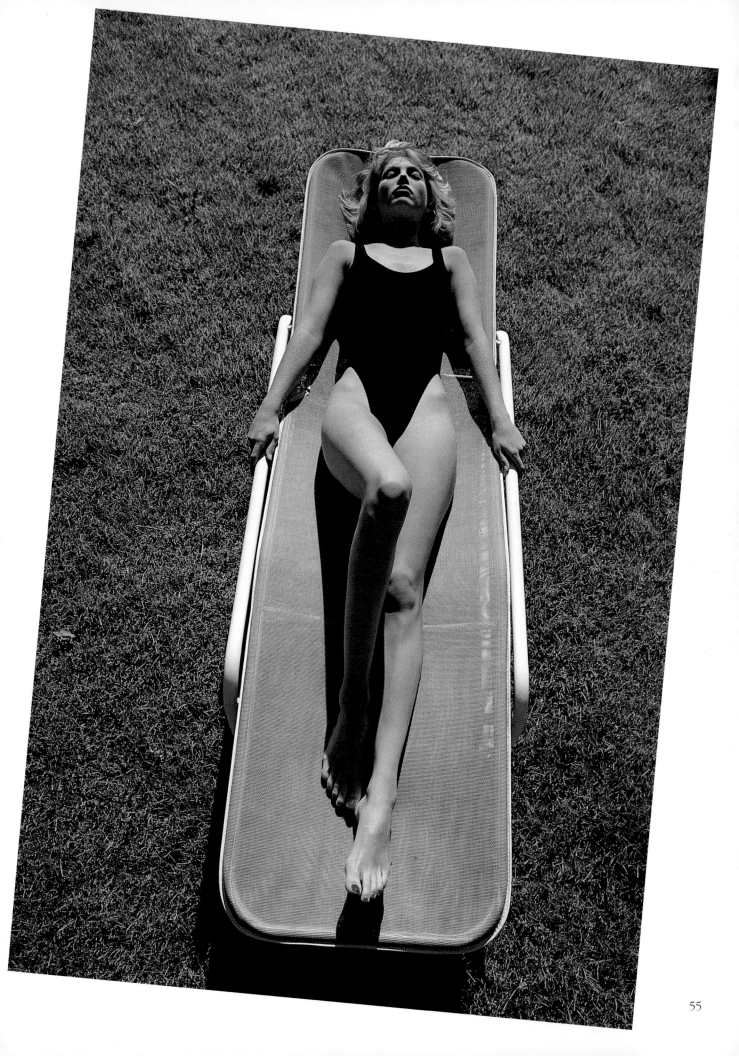

SYNCHRO-SUN

I seem to do this type of shot at least a couple of times a year. It requires the coordination of an NFL backfield, a little luck with the weather, and a final twenty-minute frenzy of activity when the shooting actually starts.

In both cases shown here, I am working with couples, a modeling situation that I discuss further on pages 136–137. In the first series, models Pat Quinn and Dawn Gallagher posed on location in Hawaii. Here, Pat becomes a sort of prop for Dawn to work against—a perfect example of the male model working well without worrying about being in the forefront.

After working for several days in the area, I knew exactly when the sun set at the end of this jetty and the shoot was planned accordingly. I prefer to start shooting a little before the sun reaches the horizon, beginning with shorter exposures and underexposing the strobe fill. This allows the daylight and strobe to combine as the main light. To maintain this balance, one assistant must take constant readings and call them out so I can adjust the shutter speed depending on the saturation I want for the background. The less available light there is, the more the strobe becomes the primary light source, until it is the only light source on the models. Working through the entire process from light to dark allows me to give the art director a wide range of choices.

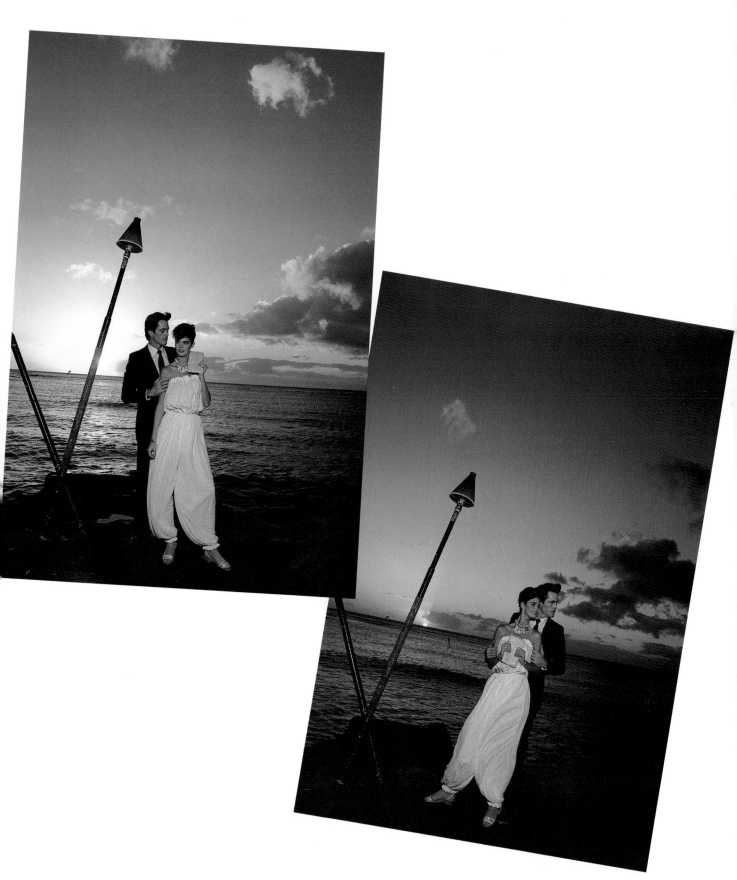

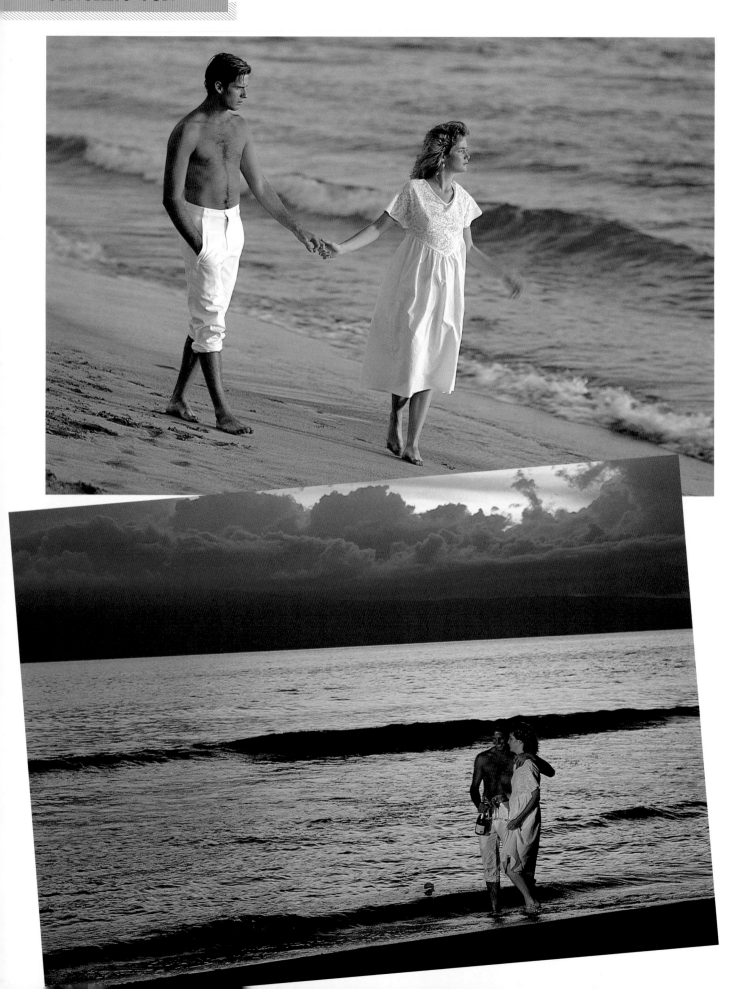

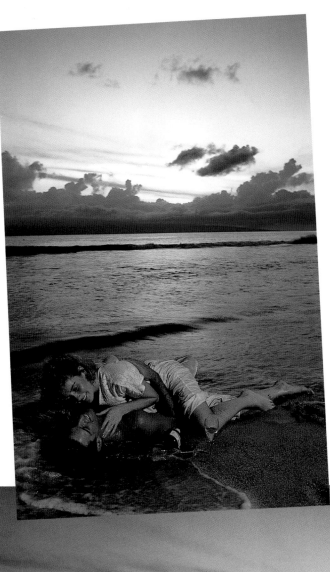

Even though this type of shot may sound easy to create, to the untrained eye the procedure usually looks like a Grand Prix pit stop being performed by a bunch of crazies. Inevitably the wind is blowing in the wrong direction, or the hair stylist is rushing in and trying to keep the model's hair out of her face, while I'm yelling at him to get out of the way because I only have one more minute of light left.

When you call it a shot, the tension breaks and everyone is ready to collapse into the nearest bar for a drink, but you walk away knowing that you've just made a very dramatic image. Everyone involved seems to get caught up in the atmosphere of the shoot, and even the models tend to project more to the camera.

In fact, with so much drama inherent in the lighting, these shots are often used to create a mood situation rather than a fashion photograph. In the second series shown here (this time taken in Maui for *Brides* magazine), I again started without a strobe and worked through the sunset. And even though we eventually lost the sunset behind the clouds, we still had enough dramatic light to work with. This couple, Nerine Kidd and John Albert, also works well together. The subtleness of the touch in the first two photographs lends an air of realism. In the final shot, she is moved to the forefront, with the male model serving strictly as a prop. ■

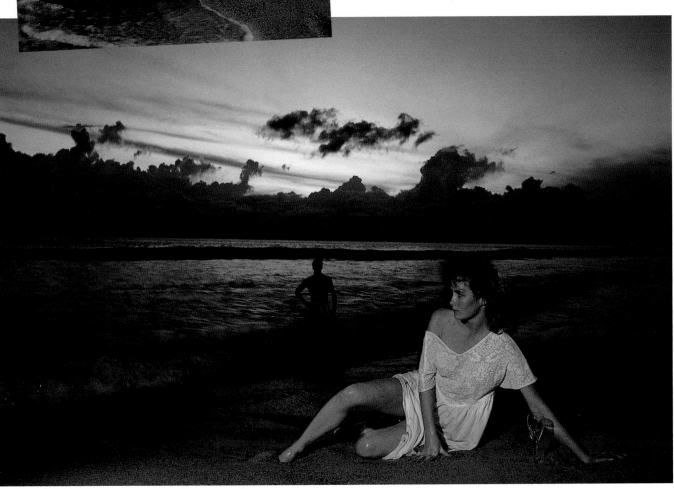

Part Two
PHOTOGRAPHING "REAL" PEOPLE

Directing people, whether they are professional models or "real" people (a term that is strange, but has become accepted in the business when referring to non-professionals), is handled quite differently by nearly every photographer. There are the screamers and the shouters, the touchers, the "method" types, and the music mavens. I guess we all have our own way of working.

I prefer a quiet, low-key approach, a little chatter, a little music—no touching. I set the pace and mood of the sessions and let the models add to it according to how they interpret my thoughts and direction. Sometimes I have to be a little more demanding if we are working to a tight layout, but even then I like to give the people I'm photographing a little leeway in their response to the camera.

Working with non-professionals is often more difficult because they are usually intimidated by the camera and have trouble relaxing. This requires more patience on the part of the photographer to bring out the subjects' personality or break through their defenses. The worst thing you can do is let your subjects see your frustration in not being able to loosen them up. If your subjects start to feel inadequate because they pick up annoyance from your attitude or your voice, they will withdraw into themselves. All you will photograph then will be a facade. If the eyes don't have a little bit of sparkle or life in them, the photograph will be dead.

The eyes are the most important area to watch when photographing any person, and this is even more true when working with celebrities or professional models. They can turn on their "look" or smile automatically, but it is usually a face with very little life. When you look at the eyes, you know they are somewhere else.

The easiest way around this is to know something about your subjects, whether they are a famous actor or actress, a singer, a chairman of the board, or maybe a housewife from Topeka. I have found that most people enjoy talking about themselves, their children, their occupation, or a favorite pastime—whatever they have great interest in. They enjoy it even more if you know something about the topic or seem interested in it. Before you know it, an unresponsive subject has become a very animated, smiling person.

I have photographed a great number of beautiful women who will never appear on the cover of a magazine or sell a product—that is not the criterion or ultimate judge of beauty. If a woman projects her beauty through confidence and attitude then that is the image most people will see.

Photographing women to make them appear beautiful is a very pleasant way to earn a living. Perhaps because I enjoy what I do so much I am able to relate very easily to all the women I photograph. There is no mystery involved in making someone look terrific—especially with all the professional help I use. Too many photographers let their own egos get in the way of the basic job at hand and, in the end, cheat their clients and subjects by taking the same picture over and over again. They are more concerned about their image as photographers than the person in front of the camera.

TWO SETS OF SISTERS

*E*ach time you add another person to the photograph, it cuts down on the number of usable shots from the take. You have added another variable, another set of possible blinks, or awkward mouth positions. The amazing thing about shooting non-professionals is that they often try to anticipate when you will shoot and they invariably do strange things with their facial muscles. That is one reason why I try subtle direction and a relaxed atmosphere on the set—wherever it is!

Meg and Beth Ruggiero, two lovely young ladies in their mid-teens, are my neighbors in Connecticut. I have tried to portray them by emphasizing their closeness as sisters, which, in itself, is beautiful. We went to the beach late in the day for a very spontaneous session—no reflectors, just available light.

They asked, "What should we do?" I answered, "Nothing, just compare notes on dates." After an awkward moment, they were engrossed in a very intimate conversation and totally unaware of the camera.

You might call it very subtle direction, or better yet, non-direction, which works well in many situations. I watched, took some shots, made quiet requests to turn or move, but ultimately let the peacefulness of an empty beach set the mood of the session.

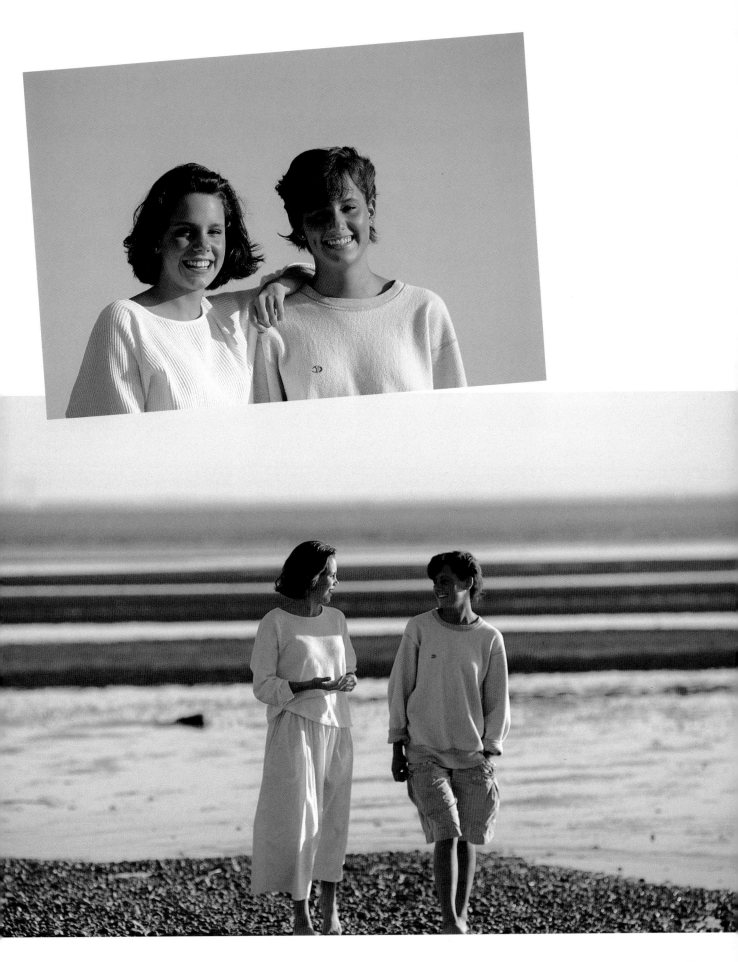

TWO SETS OF SISTERS

The Price twins, Melissa and Teresa, were photographed under different circumstances than the Ruggiero sisters, but I still think the relationship between the two girls shows through.

These 16-year-old ladies are dancers with the St. Louis Opera company in Missouri, and were photographed in the studio against a painted backdrop to suggest a theatrical atmosphere. We wanted to show them in their warm-up clothes, so we kept the look very simple. When they are practicing they usually wear their hair pulled back. We just added a little styling mousse to the hair and very light makeup on their faces. I used sidelighting here because I wanted to imitate the kind of "northlight" that is reminiscent of a dance studio. ▪

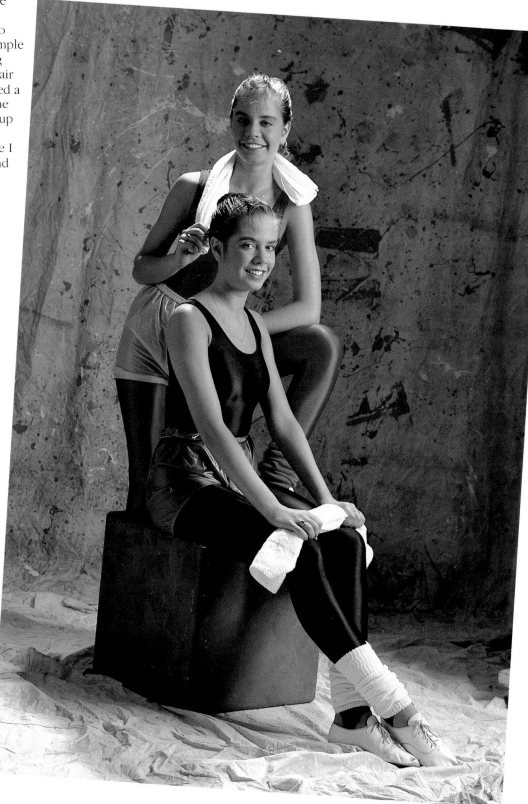

A MOTHER AND TWO DAUGHTERS

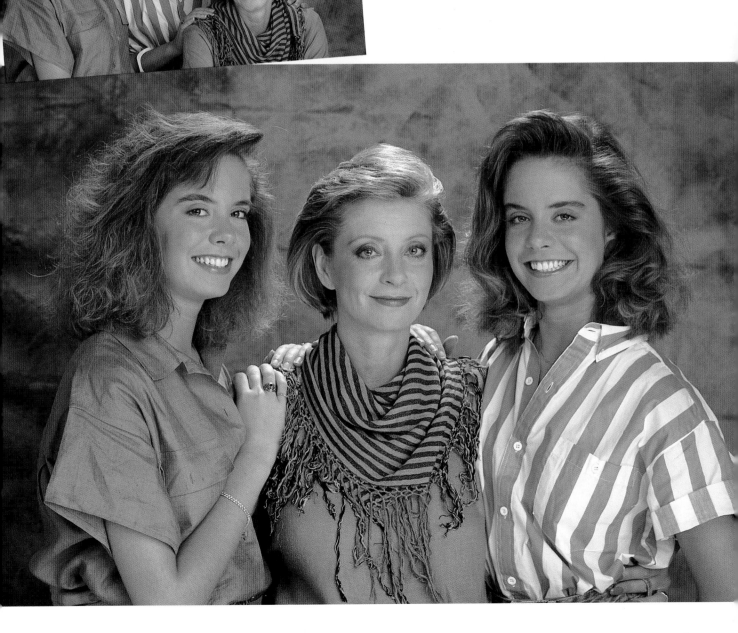

*I*n these photographs of the Price twins with their mother, Mrs. Margie Price, we changed the girls' hair styles, but the makeup was kept simple for a young, fresh look. Mrs. Price is an executive and owner of several businesses in St. Louis. Mark Schwartz, the hair stylist, Quintin Quintero, the makeup artist, and I wanted to reflect this aspect of her life in the photograph. We wanted to create a sophisticated business look, but Mrs. Price wasn't sure. To her credit, however, she finally said, "Go ahead, let's try it." ▨

FRESH, ELEGANT— THE MATURE MODEL

*R*ose Heindel, wife of artist Robert Heindel, is a vivacious, 40-plus woman who is proud of her femininity. She's taken great care of herself while raising three sons and managing her husband's gallery career.

I tried to bring out Rose's lively personality and sophistication by photographing her with a lighting setup that is generally associated with black-and-white photography. This is a much harsher light than I normally use; there are no fill or background lights involved. You could almost equate it with a stage spot but the addition of a strobe and a single, 4-foot (1.21 m) diameter white opaque umbrella directly above the camera tends to give the light a wider spread and a slightly softer look. I also used a long, gradual sweep on the seamless background. This is not a particularly flattering light for beauty shots, but some women can handle it regardless of their bone structure. Their strong personality can overpower the technique. I went with a softer beauty lighting for the head shots, using white on white to emphasize her dark eyes and hair.

Non-professional subjects often have a problem knowing what to do with their hands. Their feeling of awkwardness in front of the camera is often reflected by their hand gestures. Many times I will offer specific direction, but with Rose, I just let her go. It added a lot of natural flair to the shots of her in the black dress. ▓

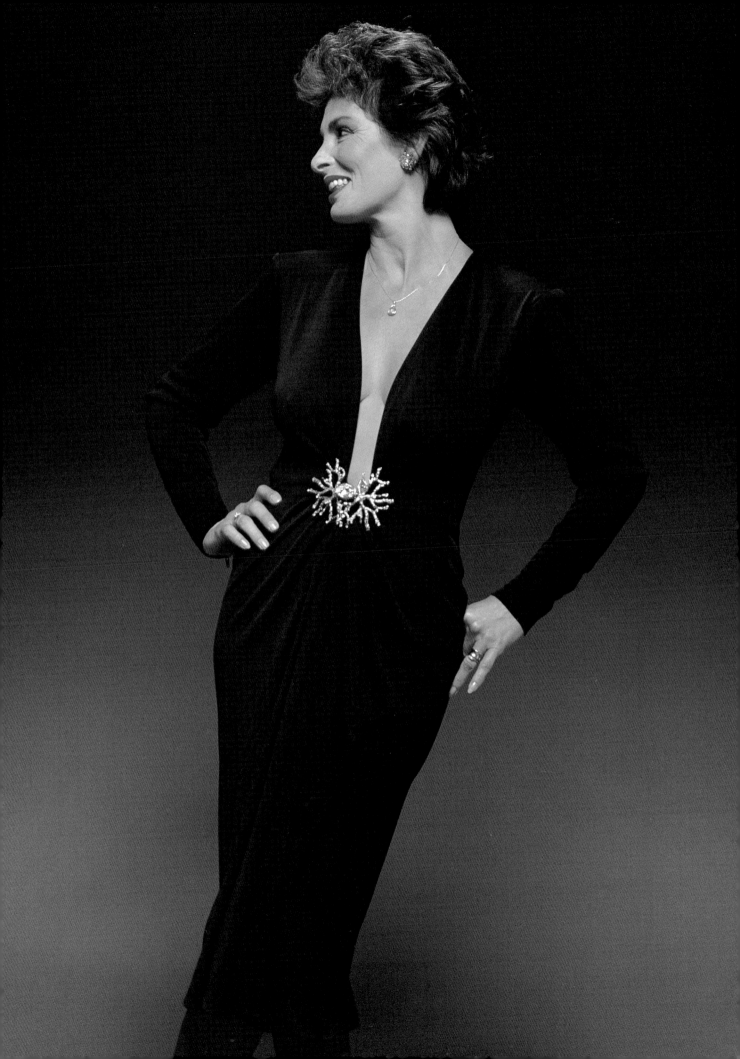

MARY DUFFY— BIG IS BEAUTIFUL!

Mary Duffy is an executive in the fashion business. She is the owner of "Big Beauties," a modeling agency for ladies size 12 and up. She feels that a woman's size should not prevent her from being stylish, and dresses to prove it. When I am working with Mary, her energy and vivacity are contagious. She exudes warmth and beauty, and has a lot of fun at the same time. In Mary's own words, "She is a 40-year-old fashion industry executive, size 16, thinks many women try to dress too young, and likes being a grown up and dressing to the hilt. Large women can carry off extra drama, especially if they project confidence!"

For the full-length photograph we used a simple catalog lighting setup, the 1200-watt-second bank was placed slightly off the camera position, and two heads bouncing off the ceiling were positioned several feet behind Mary. This ensures that none of the light spills over on her face. These heads are angled in to the center of the seamless with one on each side to give me a clean white background.

The head shot of Mary is a fairly simple beauty lighting, full bank in front, an umbrella opposite the bank, and a hair light and a background light. ■

THE ASPIRING MODEL

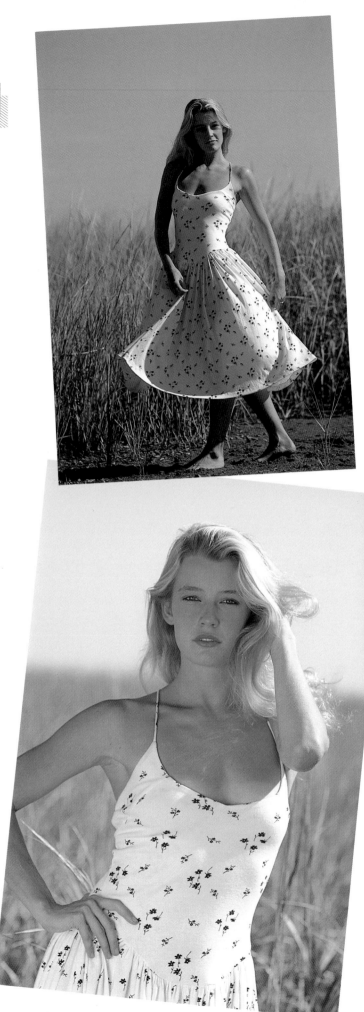

Working with someone who wants to be a model can be a long and tedious process that may never work out or may be a simple delight. An aspiring model should have a combination of self-confidence, energy, and intelligence. Throw in a little bit of narcissism and exhibitionism, mix this with the amount of self-discipline needed to take care of the body through diet and exercise, add good looks, and you just might have a model with what it takes to make it to the top. In addition, there has to be the drive for success, because making it as a model is time-consuming, hard work.

A friend knew I was working on this book, saw Candace waiting tables in East Hampton, thought she had modeling potential, and sent her by the studio. The moment she walked into the room I knew we had someone special (thanks, Michael!). Candace has many qualities that one seems to find in only a small percentage of models, and for a novice, she took to the camera immediately.

The more we worked with Candace, the more my studio staff became excited with the challenge of how far we could take her in her attempt at a modeling career. When I am shooting a roll of 120 film with an experienced model, I expect to be able to pull nine or ten usable shots from the twelve exposures; from a 35mm roll, I'm looking for 20 to 25 shots from the 36 exposures. When working with a beginner, this percentage drops dramatically. With Candace, our problem became trying to find a bad picture on the roll!

In the photographs that follow, I've presented Candace in a variety of different photographic situations. These shots also represent the type of photographs that would make up a professional model's portfolio. We started simply with the outdoor shoot and from there moved to the studio for a number of sessions. Some of these sessions were well-planned and styled, others were very impromptu.

Whether Candace continues modeling is her decision. She is faced with the choice of staying in college, or immediately pursuing a career. As I've said, it's not a part-time job, but a career that requires enormous effort. For my part, I say to Candace: "You have all the natural equipment—go get 'em!" ▪

These first shots of Candace were made at the beach. There would be time to capture the sophisticated Candace later in the studio. We wanted to start out simple—a pretty subject, a nice location, and best of all, a reason to spend a couple of days away from the city in August. I knew that she would be more at ease doing physical things, like running or jumping. She also liked being able to improvise and make suggestions for the shots. The setup therefore was almost totally spontaneous. I used a 180mm lens, while my assistant held a gold reflector to control the shadows.

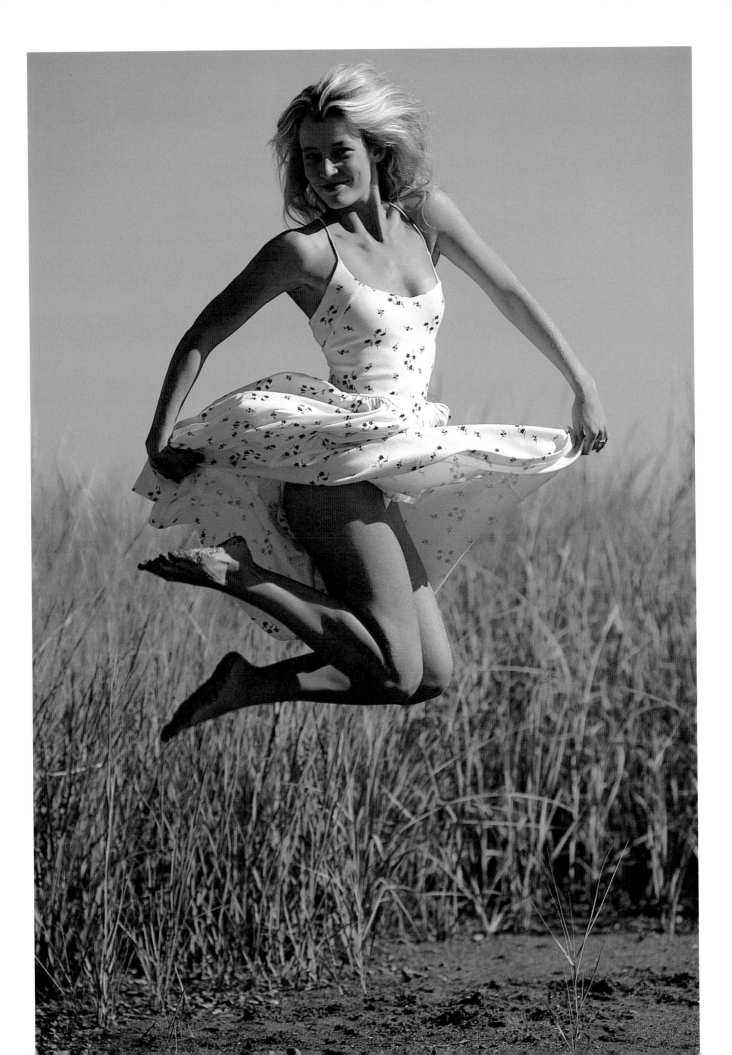

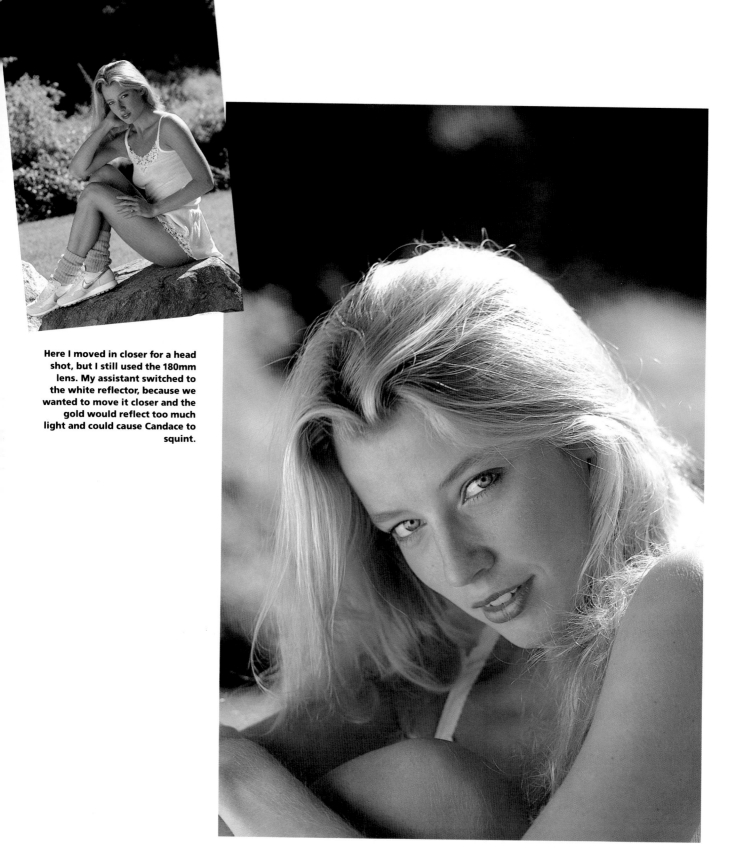

Here I moved in closer for a head shot, but I still used the 180mm lens. My assistant switched to the white reflector, because we wanted to move it closer and the gold would reflect too much light and could cause Candace to squint.

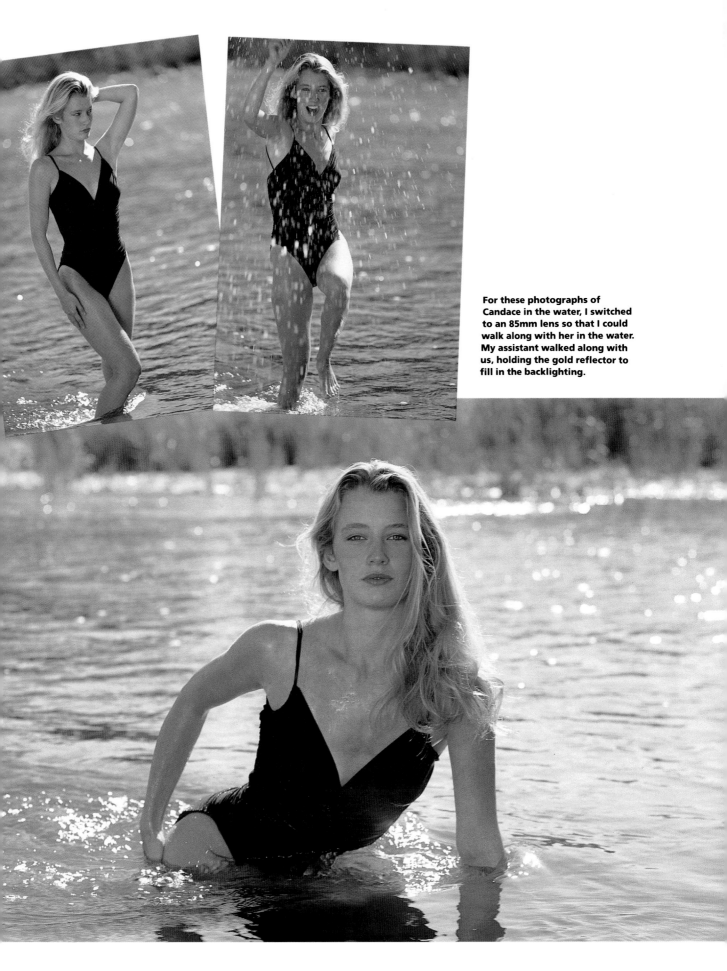

For these photographs of Candace in the water, I switched to an 85mm lens so that I could walk along with her in the water. My assistant walked along with us, holding the gold reflector to fill in the backlighting.

THE ASPIRING MODEL

We moved into the studio for these pictures, and we've begun to go a little more sophisticated. The makeup is subtle, in keeping with the quality of the light and the texture of the fur that frames her face. We were using available light in the studio, working with Ektachrome 800/1600P film. Actually, I rated the film at ISO 3200, and pushed it two stops in the processing, because I wanted to go for the extra grain, which gives the photograph a very ethereal quality. I bracketed two stops since the results are not easily controlled, but I was pleased with all the exposures. The over-exposed end has a beautiful softness and gives a high-key effect, while the under-exposed end has a somber, moody feeling. Candace was sitting next to a large bank of windows, with a fill card placed low in front of her.

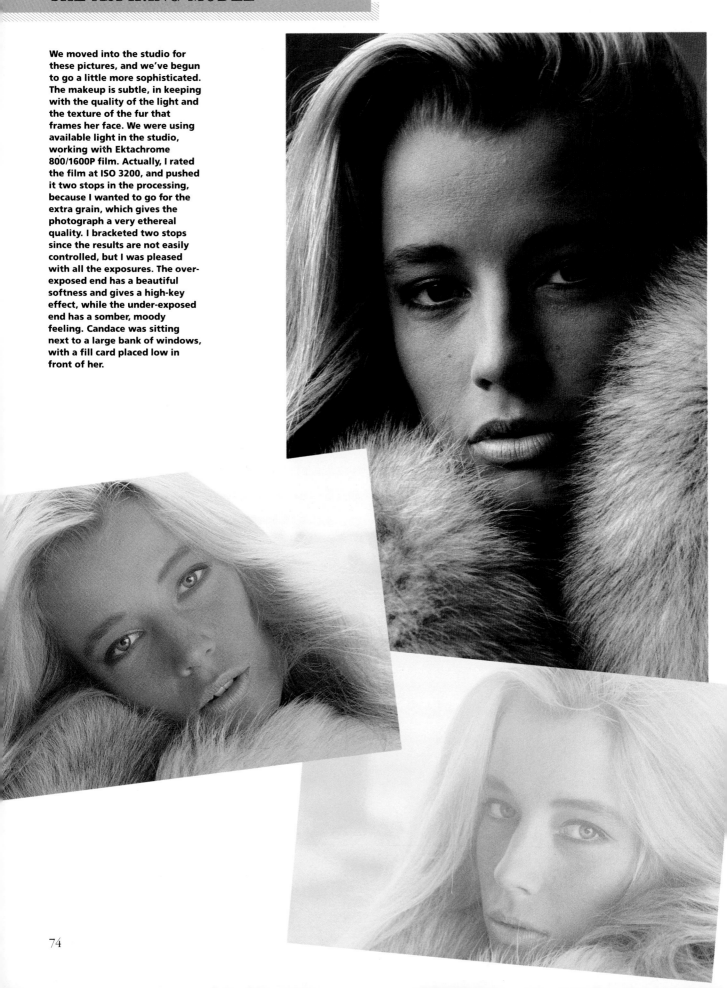

Here, Candace is sitting with her back to the late afternoon sun coming through the windows. A gold reflector was used to bounce the light back onto her face. By changing the angle of the reflector, the intensity of the bounce changes, resulting in a color change. The more direct the angle of the reflector, the warmer the color becomes.

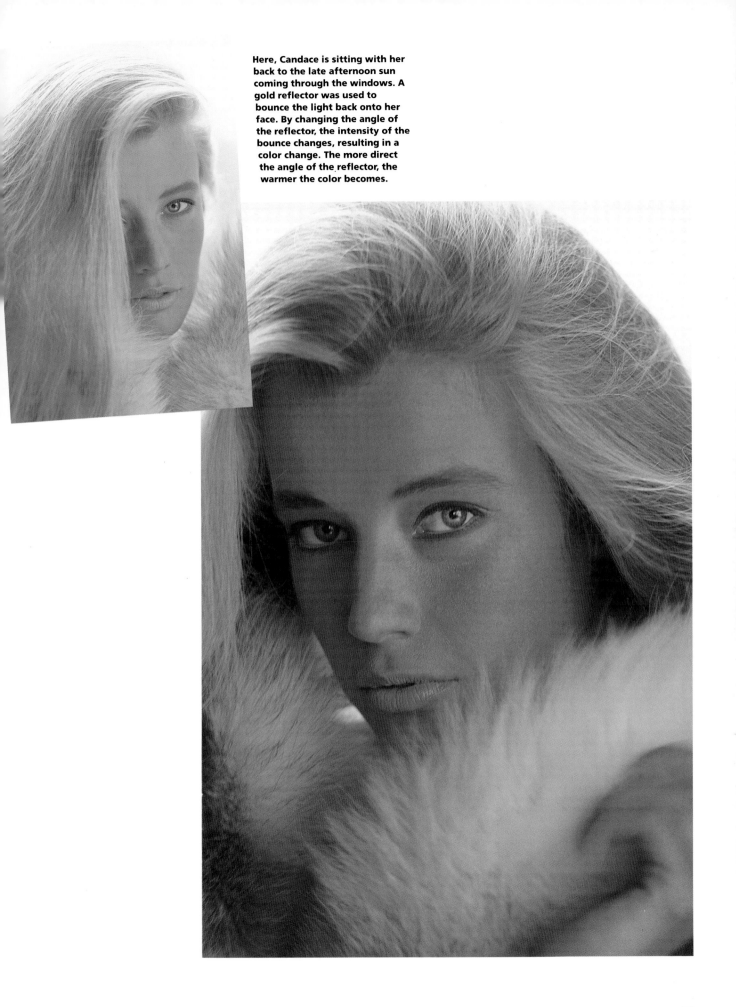

THE ASPIRING MODEL

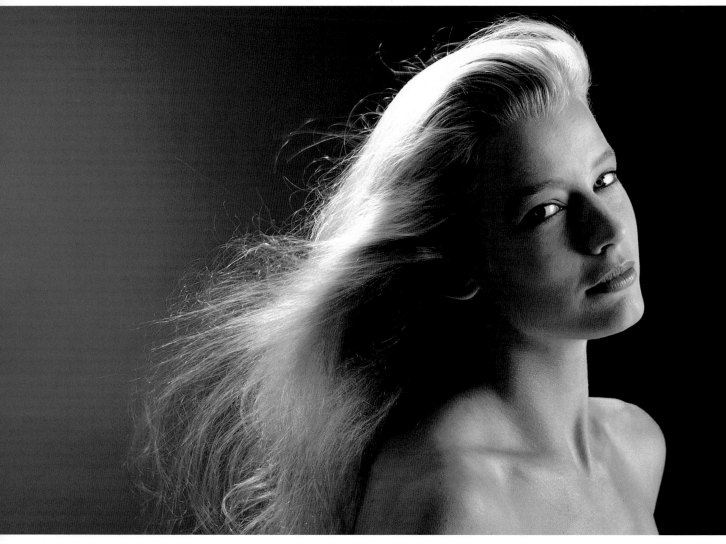

This photograph was taken with a hair product advertiser in mind as a potential client. The bank light was placed at a 90-degree angle to the camera, with a 4 × 8-foot (1.21 × 2.43 m) flat used as a gobo to keep the light off the background paper. A hair light with a wide spread was positioned about 5-feet above and slightly behind her. A single head with a blue gel was placed on the left side of the background, about one foot from the paper to control the spread of light.

After working with our discovery for several sessions, we decided to get "glamorous." I called in Leonado De Vega to do the hair and makeup, and let him perform his own magic in coordinating the makeup with the semi-iridescent blouse that Candace would wear. We also experimented with several combinations of colored gels against a red background until I found a mix that I was satisfied with. I decided I wanted a bright, clean, full light on the face, but with the slightest hint of shadow on one side of the nose for a little dimension to prevent it from looking totally flat. We used two umbrellas on the right side, one about head level and the other above it, slightly closer to the camera. Both were set at 800-watt-seconds of power. A third umbrella was placed to the left of the camera, higher than the other two and with approximately 30-percent less power. A silver fill card was placed low in front of her to bounce light onto the face. A hair light was placed 3½ feet above and about 2 feet behind her, but at low power because her hair is a relatively light blonde and a high power would "burn" it out.

At the end of a session, most models can't wait to wash all the makeup off. But Candace felt so glamorous, she left it on—stripes and all. She put on her jeans, got on the subway, and headed uptown to the Columbia University library to work on a research project. We really got a chuckle when we heard later that she had stopped at MacDonalds on the way. Did people stare? Some did—but after all, this was in New York City, where you're liable to see anything on the streets!

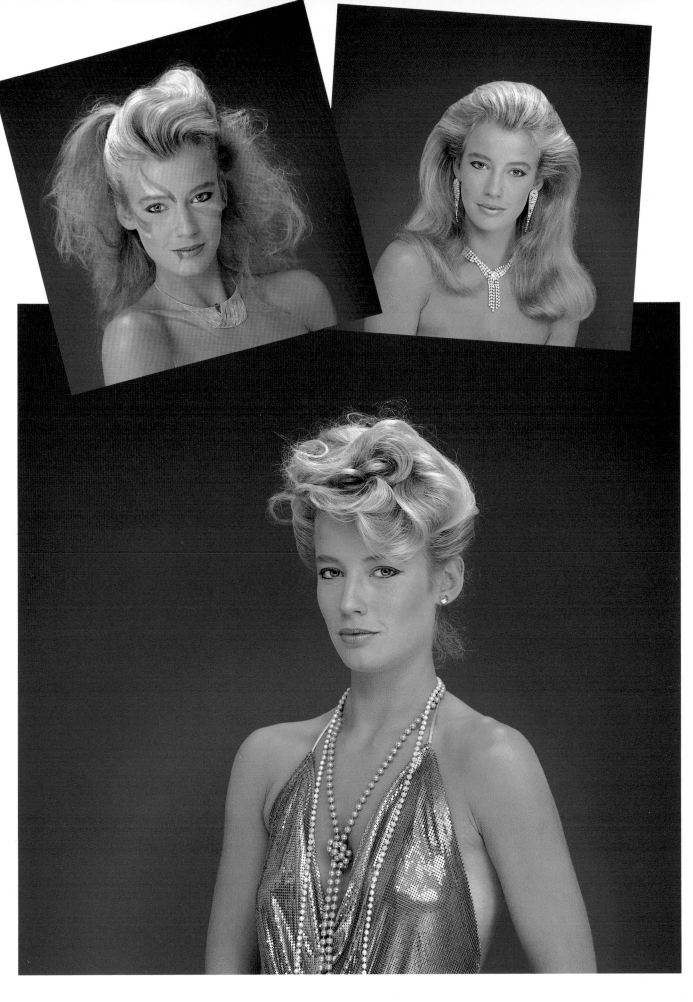

Part Three
PHOTOGRAPHING PROFESSIONAL MODELS

When I'm working with an experienced model, the first thing I do is show her the layout. If there isn't a layout then we discuss what the purpose of the shoot is—what we are trying to illustrate. I look for participation from the models because if I can get them interested or excited about the end result, they put more into it. Too many photographers treat models as mannequins and the photos reflect that attitude.

Models have to participate and think about what they are doing to project the image you want. It also makes your job a lot simpler if you don't have to tell a model how to move in each frame. Many times when I've been searching for a solution using different body movements or expressions, it has been the models who have solved the problem. Most models will want to study the Polaroids and even make suggestions. They are not only interested in how they will look but how the shot will turn out as a whole, and I give them every opportunity to help.

It's not uncommon for inexperienced people, both models and photographers alike, to try to imitate a pose that they have seen in a magazine or advertisement. All too often, these shots end up looking very forced and awkward. The photograph they are trying to copy was more than likely arrived at by a collaborative effort between the photographer and the model as they were working through a session. You usually know when the shot is working. You can feel it, even though you'd be hard-pressed to describe how you arrived at it. I try to explain to a novice that she should think of her body in terms of fluid movements, like those of a dancer, instead of trying to go into a pose that she thinks is elegant or fashion-like.

Another point I try to make to a model is that she trust me. Too many people feel they know their best angle, best expression, or the best position of their limbs. They are too concerned about how each shot will look instead of working with the photographer. I have no intention of making anyone look silly, and the editors and art directors will eliminate the photographs that are not complimentary. We are in the business of creating a successful visual image to the best of our abilities. This only works when the subject is not inhibited and will follow simple direction.

Even the best model won't look like a *Vogue* cover in every shot. Some photographs will catch a half blink or a partial smile, but you have to go through these to find out about the person you are photographing.

When I'm working with a new person, many times the first roll is just a warm-up. I'm discovering who I am photographing in terms of her facial movements. The easiest people to work with are full of self-confidence and have little concern about anyone's limitations—their own or those of the people around them.

CLOSER, CLOSER

T he ultimate consideration of whether a photograph is a tight head shot, a head-and-shoulders view, or a full figure frame is determined by the final use of the photograph by the client. As a consequence, my choice of lens depends on how I have to fill the frame.

When working in a very loose manner with a model, I prefer to use 85mm and 180mm lenses. I like to have a little space between myself and the model, because it gives the model more room to work. If I am right on top of her then all the support people are closer and it can become very claustrophobic.

When I am photographing a model from the head and shoulders down to the bust line from the same position, I switch to a 180mm lens for a very tight head shot. If I want to get even closer, I will go to the 105mm macro lens, but the optical configuration of this lens seems to flatten out the model's features if I back off and use it for a full, tight head shot. However, the 105mm macro is an extremely valuable tool for tight shots of just lips, eyes, or a combination of several close features. The length of this lens enables you to get fairly close without getting in the way of your lighting.

For a full figure photograph, I prefer the 85mm to a 50mm lens because I can crop within the frame. With the 50mm's wider angle of view, I have to work closer to crop out unwanted details or the edge of the seamless background, although on interior location shoots I frequently have to use the 50mm lens because of space limitations. I also carry a 135mm and a 105mm lens, but I seldom use them. It's just my own preference; I have friends who swear by the 105mm for head shots. ▩

Here, the 180mm lens allows me to take an extremely tight head shot, but still include the model's fantastic hair.

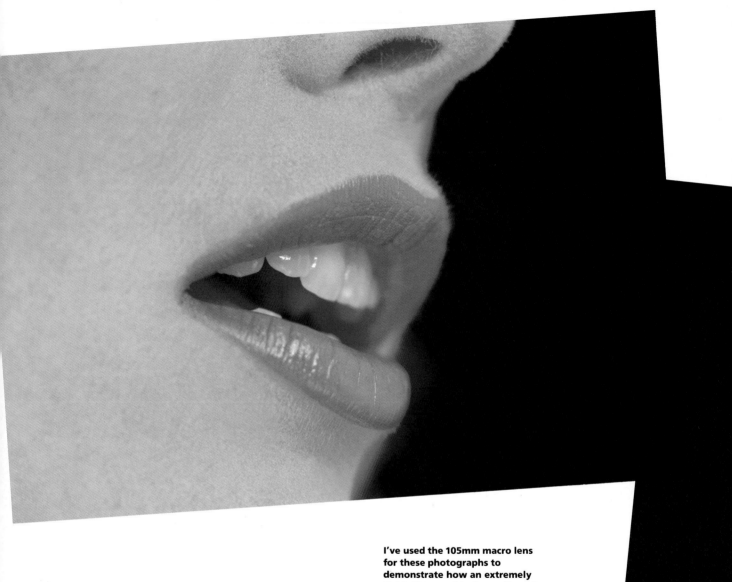

I've used the 105mm macro lens for these photographs to demonstrate how an extremely tight closeup of just a portion of the face can create some very dramatic images. Moving in tight on the model's face can illustrate a particular mood, or simply focus on very attractive features. In addition, this type of shot can be used to demonstrate the use of a product.

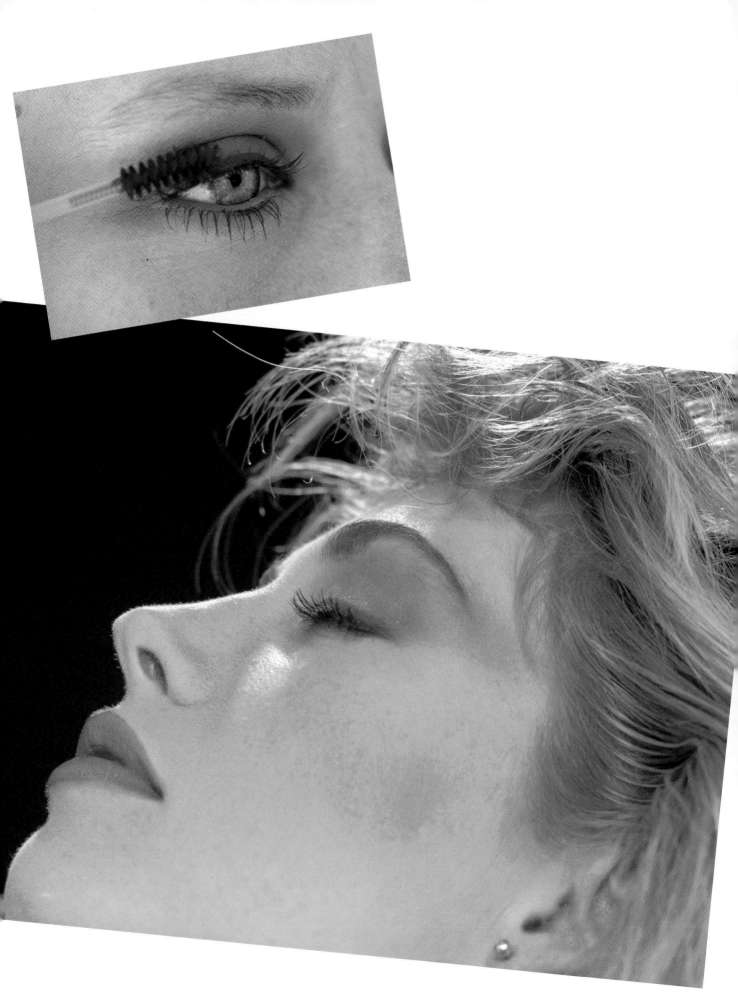

BACKGROUND DESIGN

Selecting the right background can be one of the details that make or break a shot. It's a choice that won't be noticed if you've made the right decision, but will be very obvious if you've made the wrong one. Often, the decision is not left to the photographer, but determined by the client's wishes. At *Playboy* there are never two covers in a row featuring head shots. Another magazine's editors may not want two consecutive cover shots with red backgrounds. They feel that the cover should be distinctly different from the previous one so a reader passing the newsstand in a hurry will notice it. I'm not sure if all this is part of a definite publishing science. Some editors swear by these rules and others don't give them a second thought. *Vogue* and *Harper's Bazaar* each maintain similar covers every month. Sometimes they even use the same model several months in a row.

If you're not selecting a background color according to a client's specifications, there are many methods that you can use to make your choice. It's hard to define a working rule—half the time I just wing it and go with whatever grabs me at the moment. Unless a shot is preplanned and tested beforehand, we work with the variety of backgrounds that we have in the studio.

Aside from the large selection of standard seamless backgrounds, we also have a number of painted canvases that we have created ourselves by just splashing paint on them. One of my assistants made a gray background that we frequently use simply by working with a roller, painting in different directions, and varying the amount of paint. Another background that we use was actually left in the studio by a painter who was doing some work for us. It was his drop cloth and, after using it many more times ourselves for the same purpose, it eventually ended up as a background for one of our shots. We also have a 19 × 19-foot (2.74 × 2.74 m) piece of muslin that we used specifically for one shot. It was natural in color, sort of a washed-out beige, so I took it home and soaked it in an old wash tub filled with brown fabric dye. We have been using this now for several years.

Many times, I will try to match the background color with a model's eyes or eye shadow, or a garment in the shot. But again, it's a visual judgement made at the time—I don't have any other rhyme or reason for my decision. If I have any preference at all, I do like to photograph men against a medium-dark to dark background. I feel it suggests more strength.

I will often disagree with a client's choice of background. In such cases, I always shoot it the client's way first because the decision has been made for a reason. But if it really bothers me I will shoot it my way at the end of the session and offer it to the client as an alternative. ▪

I was going for a monochromatic effect in this series of photographs of Vonnie. The black-on-black arrangement provides a dramatic effect for the evening wear, while white-on-white emphasizes the open-air quality of the sportswear.

BACKGROUND DESIGN

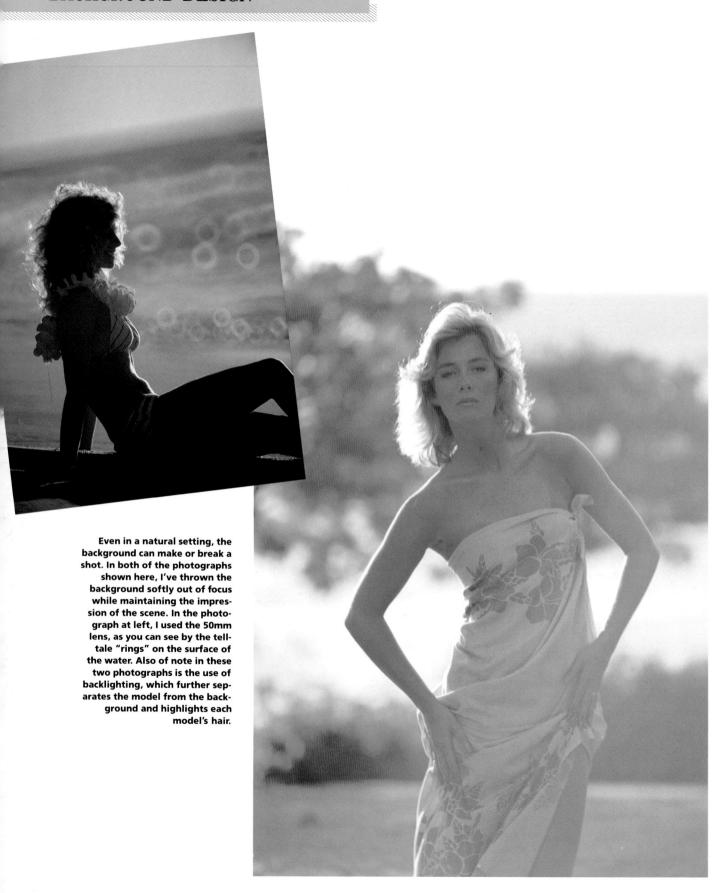

Even in a natural setting, the background can make or break a shot. In both of the photographs shown here, I've thrown the background softly out of focus while maintaining the impression of the scene. In the photograph at left, I used the 50mm lens, as you can see by the telltale "rings" on the surface of the water. Also of note in these two photographs is the use of backlighting, which further separates the model from the background and highlights each model's hair.

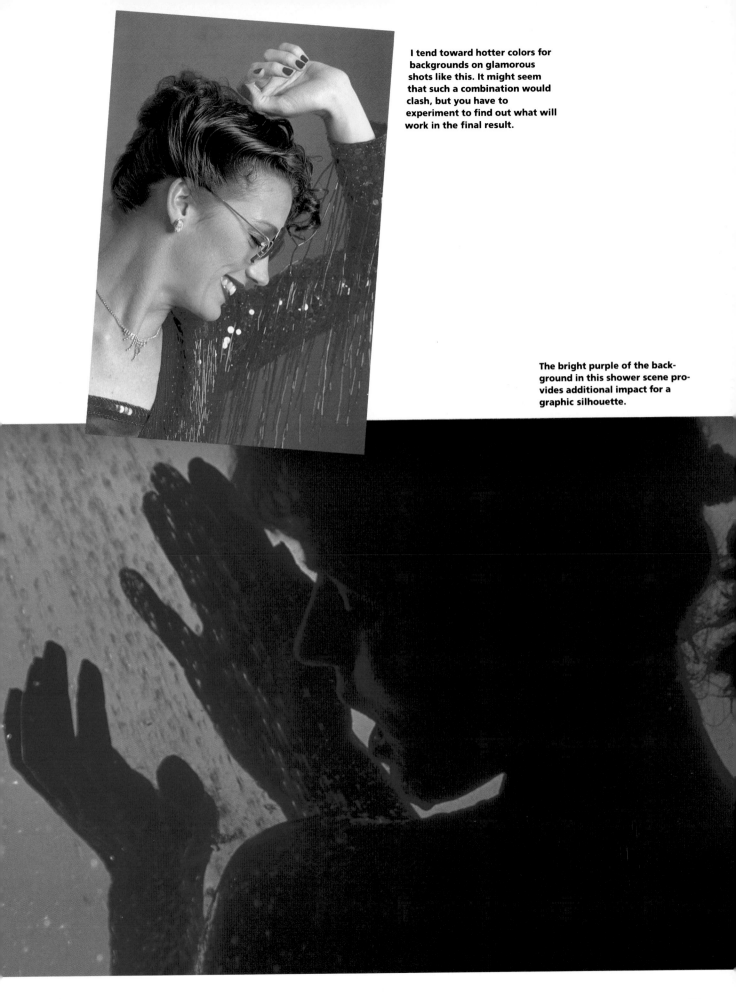

I tend toward hotter colors for backgrounds on glamorous shots like this. It might seem that such a combination would clash, but you have to experiment to find out what will work in the final result.

The bright purple of the background in this shower scene provides additional impact for a graphic silhouette.

87

SEAMLESS MOVES & POSES

A professional model is a natural in front of the camera. That is the nature of her profession. Many times, the most experienced models simply know what poses will look right, or how to perform the perfect bit of "business" that makes the shot.

Shannon and I were working on some spontaneous shots at the beach one day, when she brought out this hat. "What are you going to do with that?" I asked. She proceeded to show me.

I think the shots with the hat appear very natural and rather fetching. Photographs of an inexperienced model using such a prop could have appeared forced and a little campy. When working with a professional model, it is often best to go with the flow. ■

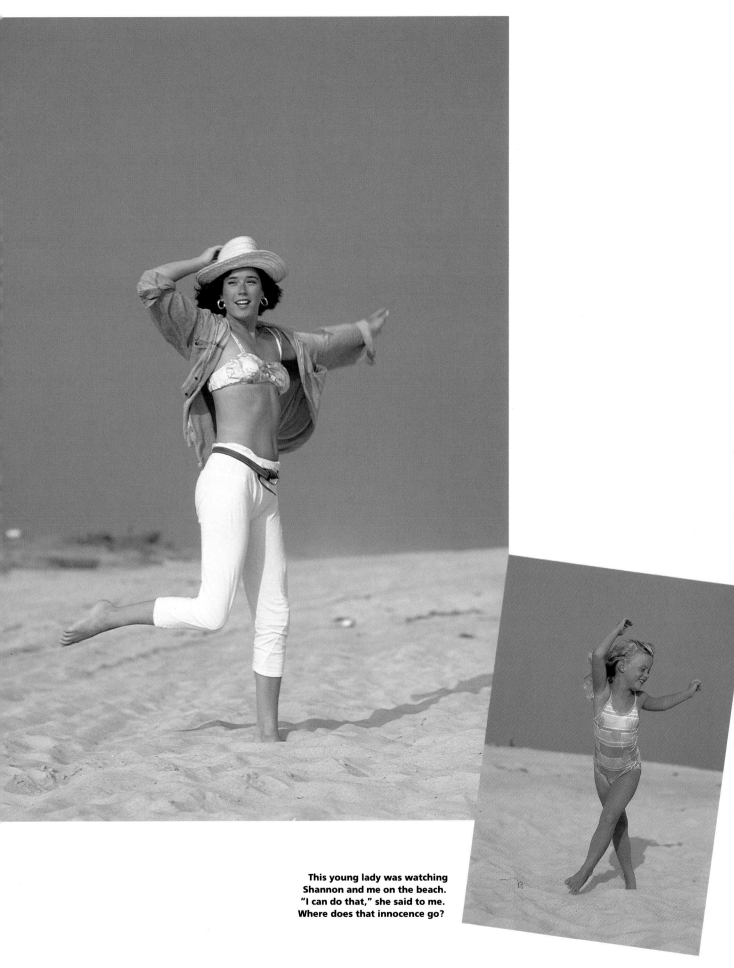

This young lady was watching
Shannon and me on the beach.
"I can do that," she said to me.
Where does that innocence go?

BODY TALK

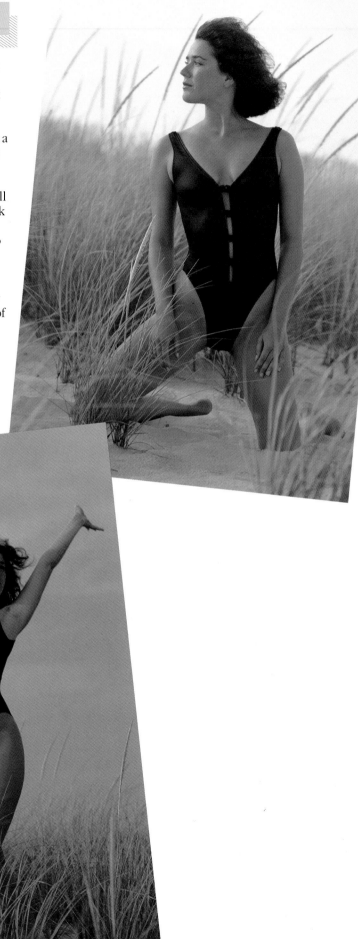

There are so many things to look for in a bathing suit shoot especially if the model is not moving. Does the suit pull in the stomach? Does she have "saddlebags" at the outside of her thighs? If she is leaning on her elbows, does it create a heavy muscular look in the upper arm? How does the collar bone area look, especially if she is in a twisted position? Each model is different but after the first few rolls I begin to see how to bring out the best look.

The line of the body becomes more important in these photographs and I'll often make a few suggestions that will help exaggerate the hip line or make the model's legs look longer. In some instances, I'll want the body to appear simply as a sensual form, or a design element in a shot, so any awkwardness of pose can throw off the lines of the body.

Most of the models know their own shortcomings and will point them out to you. Some problems are not nearly as bad as they make them sound, but if you have dozens of people tell you your thighs are a little on the heavy side you become more aware of them than necessary.

Too often clients and casting people look so hard for perfection that many girls who would be wonderful for a particular shoot are turned down because of some personal hang-up of the "caster."

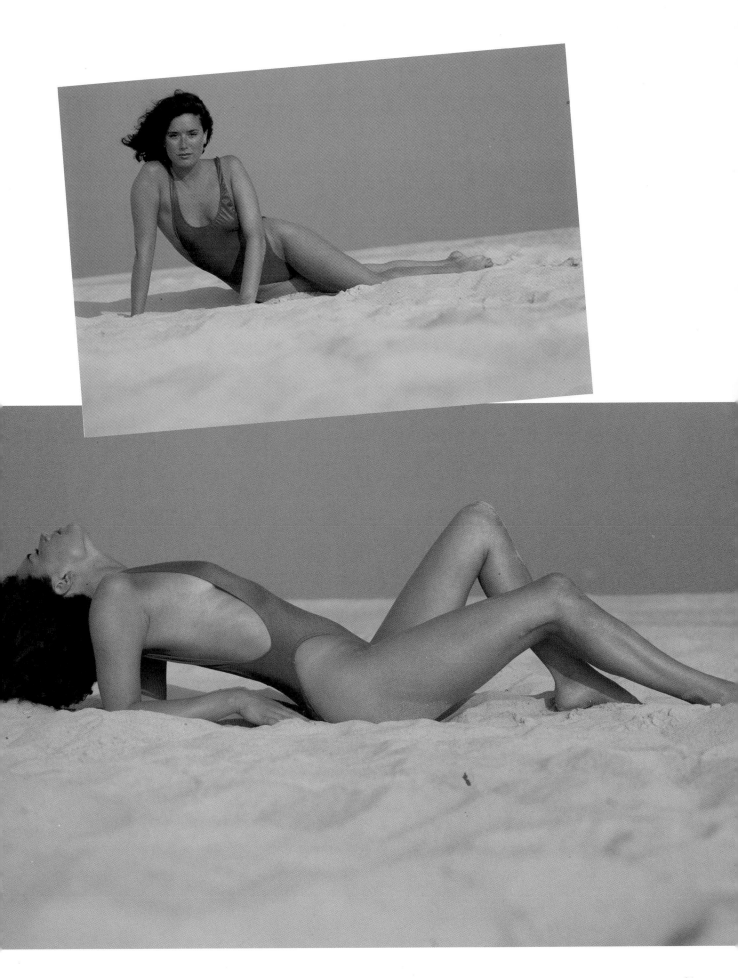

BODY TALK

In a dramatic shooting session like the one shown here, the model's pose can really make or break a shot. Actually, this was a rather impromptu session—model Brenda Harris came by the studio one day after a bathing suit "go-see" for another photographer. I had nothing scheduled so we decided to take some photographs. I happened to have four sheets of 4 × 8½-foot (1.21 × 2.58 m), thunder-gray foam core, which we arranged in the shape of a box. We greased Brenda with baby oil and started the shoot. After a couple of rolls of film, I decided another element was needed, so we added the cherries, which were left over from the previous day's shoot. The bank light was placed directly over the model's head, with the face of the bank parallel to the floor. We used the 2400-watt-second heads, because they happened to be hooked up at the time.

The only problem we had was with the bathing suit. All of the new suits that are cut above the hip line have a tendency to wrinkle if the model is not standing. The suit will tend to sag without the stress across the front of the lower body to pull it flat. ▨

My stock agency, **The Stock Market**, sold this first pose to *Today's Photographer* for a cover. They were sent twenty takes from the session, but selected this one.

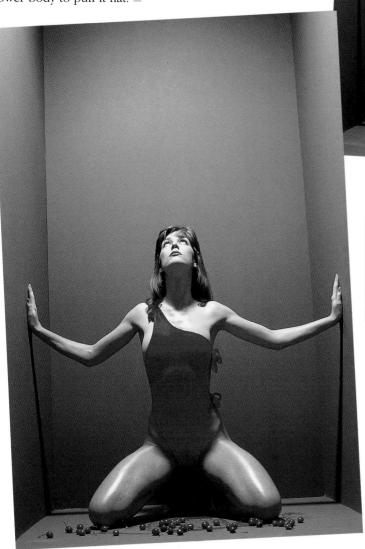

Even though this shot is similar to the first, it is my favorite. I like the pose, and feel that the cherries help add interest to the photograph. I used this for my promotional ad in *The Creative Black Book* one year.

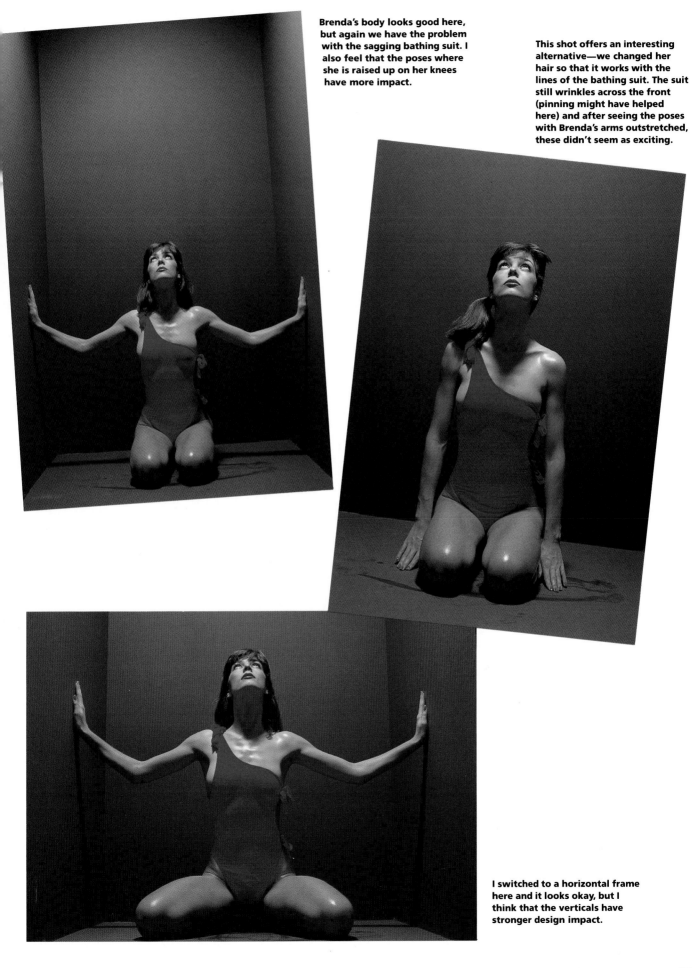

Brenda's body looks good here, but again we have the problem with the sagging bathing suit. I also feel that the poses where she is raised up on her knees have more impact.

This shot offers an interesting alternative—we changed her hair so that it works with the lines of the bathing suit. The suit still wrinkles across the front (pinning might have helped here) and after seeing the poses with Brenda's arms outstretched, these didn't seem as exciting.

I switched to a horizontal frame here and it looks okay, but I think that the verticals have stronger design impact.

ON LOCATION

Some of my favorite photographs are "out-takes," the results of extra shooting done while on assignment. This particular group was taken while on a shoot for Fred Perry Sportswear at Club Med in Playa Blanca, Mexico. The trip included a "cast of thousands": six models, a stylist, and representatives of the advertising agency and the client—thirteen in all, plus myself and an assistant.

I work quickly when I'm on assignment, especially in this type of climate. I'll usually start shooting at 7:00 AM, quit around 10:30 AM, then start again at 3:00 PM and work until sunset. I have everything planned on my end so that the shoot works like clockwork. This is to allow time for the problems—a garment that doesn't fit right or a model wearing the wrong color—that will arise. These situations consume more time than average sessions.

I had promised the models some test shots if time permitted. At the end of the shoot, we did have a day off. We relaxed by the pool and I took some casual photographs. I had used all my film, but one of the models had a couple of extra rolls of Kodachrome 25. She had asked me to take a couple of "snapshots" of her and some of the other models playing in the surf, which I did. Then, as my assistant, Robert, and I were walking up the beach to our rooms, I saw the perfect photo opportunity.

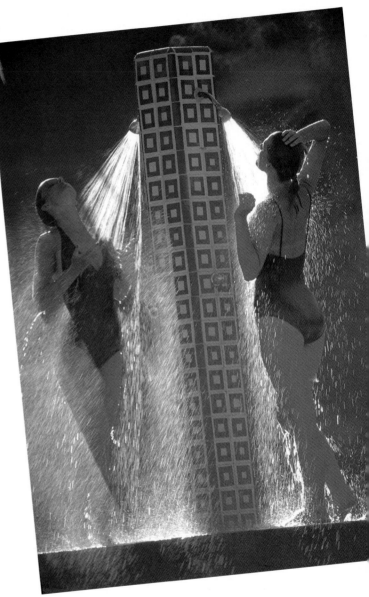

It was around 4:30 PM and the beach was in complete shade. I looked up to see the sun just starting to peek through a cleft in the mountain. At the same time, the models were under the shower at the edge of the beach, washing off the sand. I told Robert to run back and tell them to stay under the shower for a few minutes and just slowly revolve.

I knew that in a few minutes the sun would sink behind the mountain, so I had to work fast. Besides, I only had about twelve exposures left on the roll. I carry a couple of my old Nikon Fs when I know I'll be working in sand, and they don't have built-in meters, but I knew that I wanted to shoot from a position where the shower would be totally backlit. To make matters worse, I had my 500mm lens on the camera, so I ended up running all the way out into the water to get a full image in the frame. There was no time for a reading, and no one could hear me over the roar of the surf anyway, so I guessed at the exposure and started shooting.

It was all over in about three or four minutes. I was soaking wet but tickled pink! And I have to confess (now that a few years have gone by) that I was more excited about the results of this last session than I was over the previous ninety shots taken for the client. ∎

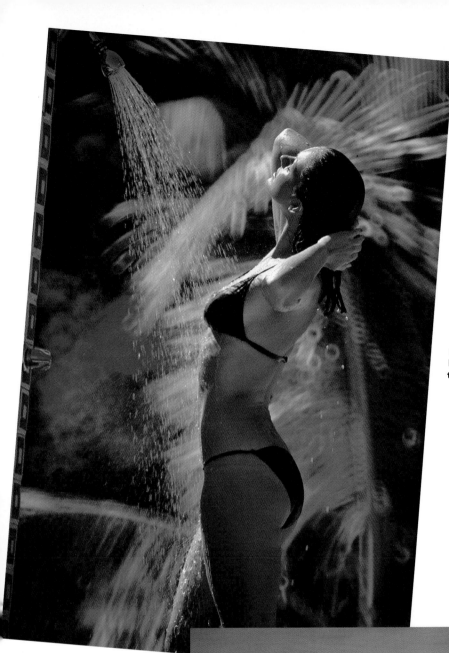

This is a shot I had taken earlier in the week of one of the models in the same shower. It was around 2:30 PM, just before the afternoon session was about to start. You can see by the background that it was also taken with the 500mm lens.

Here's an example of the real reason we were down in Playa Blanca—a take from an actual shoot for Fred Perry Sportswear.

COMPOSITION

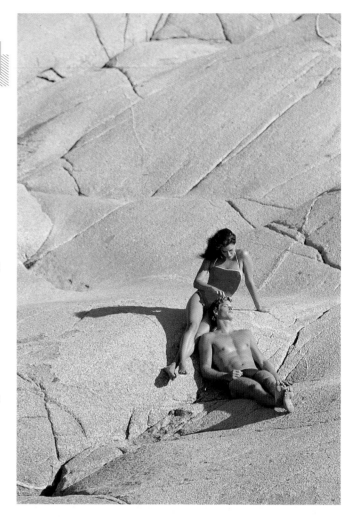

Photography is a way of life for me, not just a job. I would be so frustrated if I were somewhere and saw a great shot, but could only bring back a description. I also like to occasionally shoot whatever strikes my fancy. It is therapy; a break from shooting for layouts and worrying about magazine gutters or where the type will fall in the final advertisement. There are times when I have explored a small section of a beach for hours at a time, shooting a half-dozen rolls of film of what I call "nuggets." I have a lot of nuggets at this point in my career, and I love every one.

People often think that the photographer's job is much easier when photographing a beautiful model. Just as much planning and thought goes into the composition of these photographs as any other kind. But even when I'm shooting for myself, I'm still thinking about how all the elements are placed in the frame.

For the last five or six years, my advertisement in *The Creative Black Book* has consisted of a series of photographs placed in a grid-like fashion on a double-page spread. The background is a carefully chosen photograph that lends itself to the design of the ad. This design became so recognizable after I first began to use it that art director Joe Phair, the originator of the concept, felt I should keep using it for continuity.

So during the course of the year while I'm on various assignments, I'm always keeping my eyes open for *the* background shot. It's a difficult shot to make because the background has to be simple enough for the other photographs to drop in without competing in color, yet strong enough not to get lost. ■

These photographs were taken with an 85mm lens while on assignment in Nova Scotia for *Brides* magazine. We had covered most of the island in the course of the week's shoot, but when we arrived in Peggy's Cove I felt the background of the rocks would be perfect for my ad. I took a number of shots of Shannon alone and with a male model. I preferred the female by herself, but deferred to Joe, who felt the couple would be best.

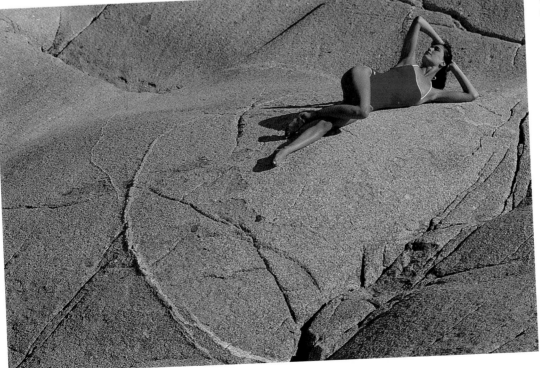

COMPOSITION

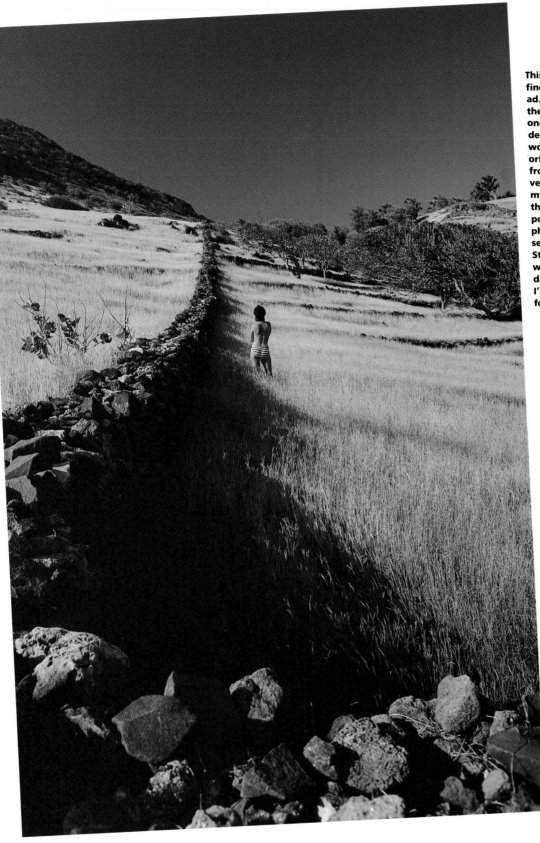

This shot is the result of trying to find *the* background shot for my ad. However, I really looked at the scene through the viewfinder once the model was in place, and decided that the background would be too busy for my original purposes. I changed from the horizontal framing to a vertical and made the shot for my portfolio. It was taken with the same 85mm lens with polarscreen as the Nova Scotia photographs, but this time the setting is the Caribbean island of St. Barts, and the model is my wife, Carol instead of my daughter Shannon. (Even when I'm on vacation, I'm still looking for that background shot!)

Many times I'll use a pretty face merely as an object to carry off a photograph. In this photograph I was working with the graphics of the color combinations. I used a polarscreen filter on the lens, which strengthens the color design. The beauty of this shot is in the abstract form. The personality of the subject does not show through.

Part Four
COMMERCIAL ANGLES

Professional photographers spend most of their early career finding a style, putting together a portfolio that reflects this style, and honing their creative abilities to a sharp edge so that they can instantly come up with an idea or a direction for a photograph. Unfortunately, to be a commercial photographer, one must work for a client, and one of the sad facts is that when photographers are finally at a point in their career when they can contribute the most, they are asked to contribute the least.

With all the sophisticated test marketing and research that is done in advertising today, many times a simple decision that should be left to the people who have been specifically hired to perform that task is made by committee. This either over-complicates the shooting session or eliminates any chance of spontaneity. Such constraints are more prevalent in the advertising end of commercial work than the editorial, which is one major reason why many successful advertising photographers will always accept editorial assignments.

The control over the look of an advertisement should belong to whoever is writing the check. The production and creation of that look should be in the control of the ad agency, art director, or designer. The actual execution of the look is finally given to the photographer and many times he is the last person to become involved. This is unfortunate, because his ability to contribute more to the photograph than just the technical execution is seldom utilized.

I am fortunate to have a handful of advertising clients with whom I have worked for a number of years who still count on me to come up with a photograph that will illustrate what they feel about their product or company. These relationships are built on consistency and trust, yet I am constantly pushing to go a little further with a concept or try a new direction. Sometimes they listen and sometimes they disagree, but that kind of give-and-take is what makes any professional relationship work.

I must say that beauty and fashion advertising work enable the photographer to exercise more creative input and control because an inherent part of the advertising is to show what's new and exciting in terms of current trends. However, the fact still remains that editorial work will always allow the photographer the most freedom.

The disparity in the financial arrangements between advertising and editorial work is ludicrous in most cases. It is not unusual to create a shot for a magazine that would bring you maybe ten times that amount for an advertising job. Many photographers are willing to stretch the budget for a chance to work on something that is visually exciting, since editorial art directors are usually responsible for starting any new trends in the direction of photography.

Editorial art directors are often willing to try something new because they have to deal with the same subjects every month—especially in women's magazines. Most art directors of major consumer magazines seldom have to answer to more than one or two people above them, usually the editor or the publisher. And since they don't have to answer to a client, they have the advantage of being innovative without the fear of losing the account. Their aim is to provide visual variety and they count on the photographers, illustrators, and designers to contribute creatively.

PRODUCT ADVERTISING

*P*roduct advertising can provide the photographer with a number of constraints. Aside from all the other concerns over placement of type, horizontal or vertical format, and other restrictions based on the layout, the client may introduce other worries. They wonder if the model will present the right image for the product, or if her good looks will overpower their product in the final ad. They don't want the shot too sexy, but not too plain either. Every photographer encounters these problems at one time or another.

But there are times when a client has the intelligence to trust the photographer's good sense, both practically and visually. The photographs shown here are the result of working with just such a client.

I have been working for Liberty Optical, one of the largest independent manufacturers of eyeglass frames, for over ten years. When I first started working for them, everything had to be shot in the studio on 2¼″-square film. Originally, we worked with no lenses in the frames, and an optician was present who would constantly jump into the shot to make minute adjustments on the model's glasses.

I built up a relationship with the client in time, and was finally able to get rid of that optician. Next, I got them to leave the lenses in the frames for a more realistic look. Last—and best of all—we switched to a 35mm format and started shooting more spontaneously. We would agree on a direction or mood, cast the right models to express the idea, and then pick a location that would afford a number of different types of shots. ■

We had been working in the studio when the sun started to come in and slant across the wall. We quickly shut down the strobes, moved model Leah Jensen into position and started shooting. My assistant grabbed a couple of colored poster boards and held them in place and we had two pretty pictures. I could not have tried to explain a shot like this beforehand, but the client has grown to accept the advantages of "winging it."

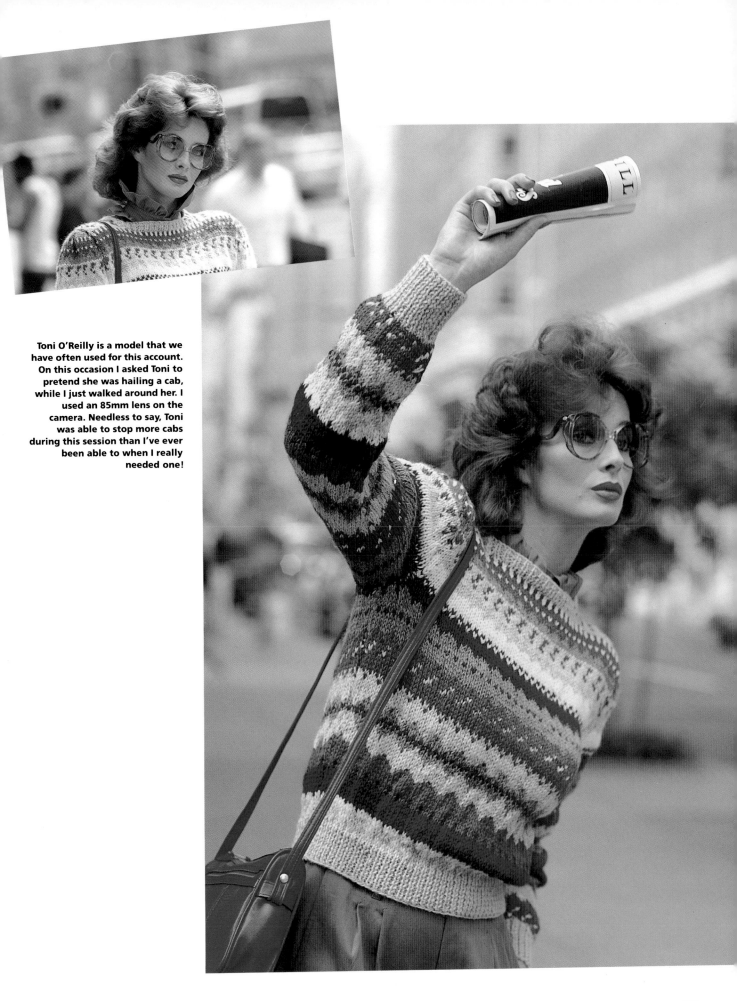

Toni O'Reilly is a model that we have often used for this account. On this occasion I asked Toni to pretend she was hailing a cab, while I just walked around her. I used an 85mm lens on the camera. Needless to say, Toni was able to stop more cabs during this session than I've ever been able to when I really needed one!

The photograph shown above is a "grab shot" taken while working on location. A group of construction workers walked past while we were shooting and model Patti Quinn simply grabbed the hard hat off one of their heads.

Many times the client will want to feature a certain part of the frame. In this case, I used a top light to accentuate the fancy temple piece of the eyeglasses.

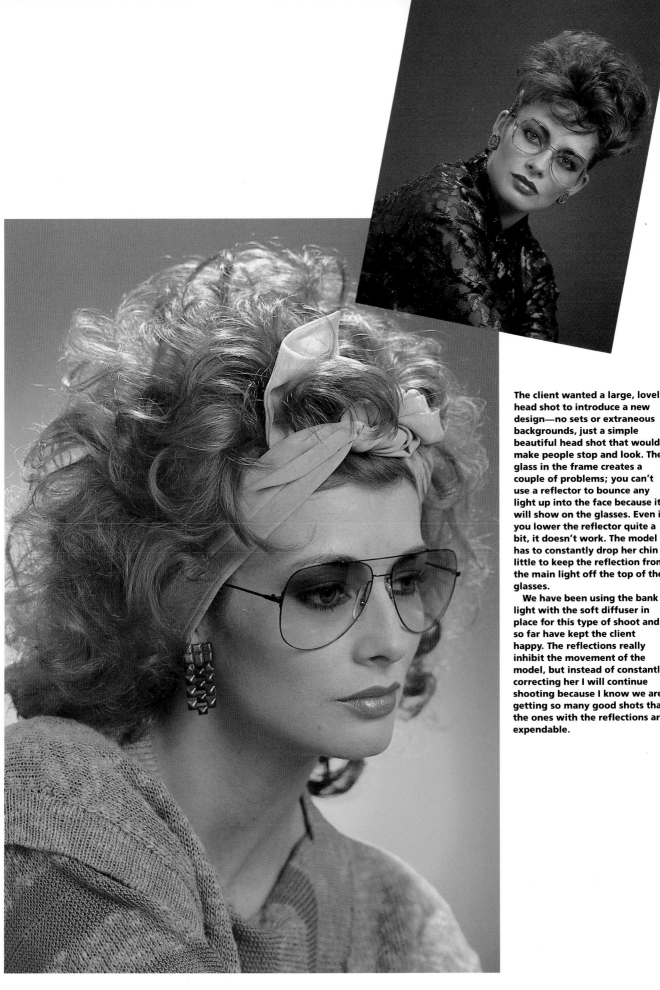

The client wanted a large, lovely head shot to introduce a new design—no sets or extraneous backgrounds, just a simple beautiful head shot that would make people stop and look. The glass in the frame creates a couple of problems; you can't use a reflector to bounce any light up into the face because it will show on the glasses. Even if you lower the reflector quite a bit, it doesn't work. The model has to constantly drop her chin a little to keep the reflection from the main light off the top of the glasses.

We have been using the bank light with the soft diffuser in place for this type of shoot and so far have kept the client happy. The reflections really inhibit the movement of the model, but instead of constantly correcting her I will continue shooting because I know we are getting so many good shots that the ones with the reflections are expendable.

THE RIGHT CHOICE

For this series we wanted to emphasize the graphic quality of the swimwear. Model Lydia Wendt was chosen because she had naturally strong good looks that would not overpower the product. The makeup-and-hair stylist was told to do something interesting that would complement, but not overwhelm, the headgear. The choice of lighting and background was also kept simple. ■

Since we were photographing action-oriented sports gear, we tried to add a little bit of motion to some of the shots. I asked Lydia to swing her head, and used a slow shutter speed of ¼ sec. This enabled me to pick up the motion in the earring and a slight ghost image around the head and within the eyes, while the strobe stopped the basic action.

The tilt of Lydia's head creates a strong graphic look here. The single red earring was added for additional impact and to fill the negative space.

After several Polaroid tests and a couple of attempts to warm up the light with bounce cards, I swung around to a totally natural backlit situation. One gold reflector was placed behind her, with another placed under the chin, and I shot wide open with an 85mm *f*/2 lens.

CARTE BLANCHE ASSIGNMENTS

The real joys of advertising photography come when the photographer gets a completely open-ended assignment. The only problem in doing shots like this is having to go back to the constraints of the average campaign.

The client was a major printer of fine art reproductions who wanted to move into the more commercial areas of his field. His request was for a photograph of a pretty girl, showing enough skin to give him plenty of skin tone to work with, a bright color for the background, and something in the frame that would be tiny in size—all to illustrate his expert abilities as a printer.

For the first couple of days I drew a blank. I worked on other projects but kept this one kicking around on the back burner. When I run into a photographic problem that isn't gelling immediately, I usually work out the solution by getting out of the studio and wandering around museums, galleries, or stores. While I was browsing through Macy's department store (the world's largest prop shop), I noticed a whole counter full of perfume atomizers in the beauty department. I immediately knew what I would do for the client. Certainly the fine mist from a spray of perfume would be a fine enough element to show his talents.

My next step was to find a model who would help execute this concept. I wanted someone with a long neck and lovely profile, so I selected model Cynthia Shaffer. Before the shoot, we did a test with the atomizer to see if we could catch the mist on film. At first we used a single head, placed on a boom and firing through a snoot, but it didn't give the results we wanted. The solution was to move the head behind the model, using a bare bulb firing at 400-watt-seconds to give us the maximum illumination needed to capture the finest droplets of spray. The main light was the bank, placed above the camera and facing straight in to give fairly flat lighting for smooth skin tone.

Clorinda, the makeup-and-hair stylist, provided an even foundation of makeup running from the face, down the neck, and across the shoulders. Cynthia provided her professional, elegant attitude and good looks, which made it all very easy. ■

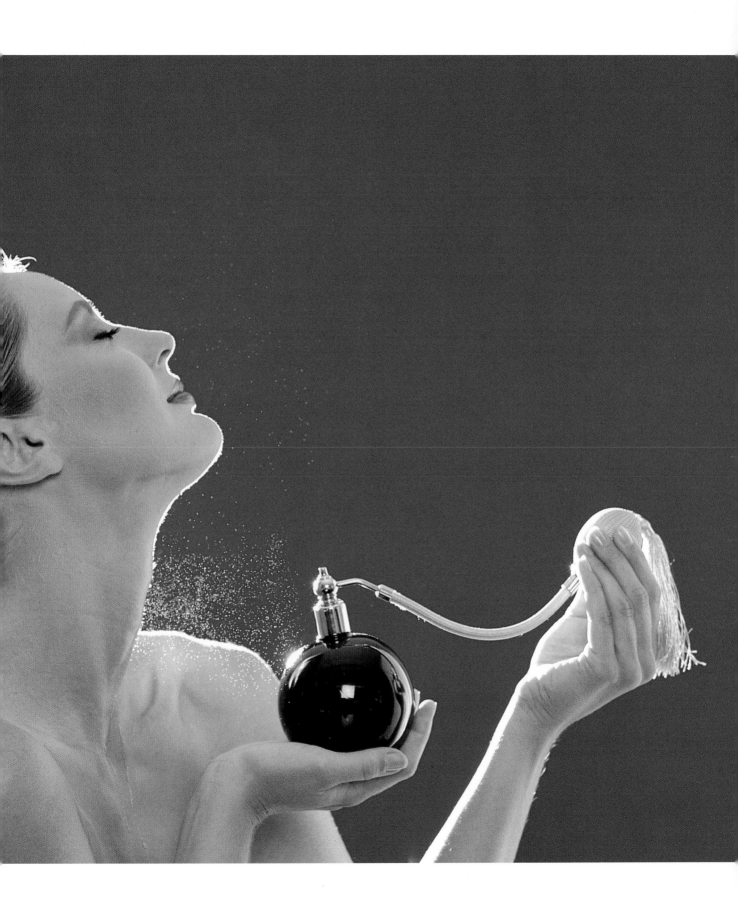

WEIGHING PRIORITIES

With product advertising, you often have to achieve a balance between showing the product off to its best advantage and having the model assume a stance or look that best projects the image of the product.

These photographs of Laura White were actually taken for inclusion in a guide book to South America published by Braniff airlines. One of the stops on the Rio tour was the international headquarters of H.L. Stern, one of the largest gem dealers in the world. The conditions at their offices were too cramped to allow for the pretty beauty shot they wanted, so I convinced them to let me do the shot in my studio when we returned to New York.

They sent the aquamarine necklace down to the studio with an armed guard and gave us an hour to complete the shoot. I used an 85mm lens, with a bank light directly over the camera, and a silver fill card in front of Laura. A bare bulb was placed behind her head. I added a soft focus filter to give the necklace a little sparkle, but we didn't want the lighting to become too dramatic, as that would have made the shot look like a jewelry ad. Laura was actually the focal point of the photograph, featured as a tourist buying the necklace in South America. ▦

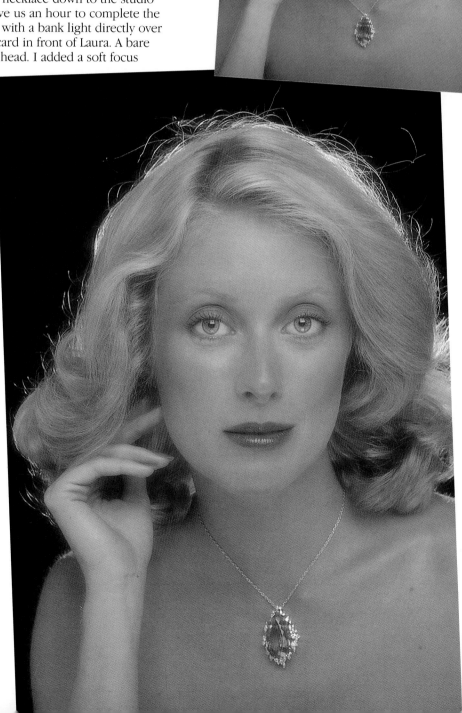

LINGERIE

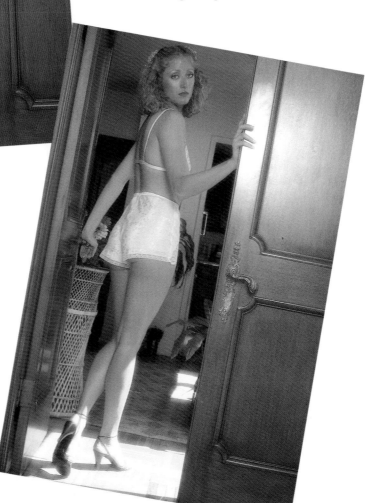

hotographing lingerie is similar to other types of fashion work. There are manufacturers who simply want you to suggest a style or look, and there are those who want to see every stitch of their handiwork, but no wrinkles. Fortunately, this client, a distributor for specialty shops in the Caribbean and South America, fell into the first category. He simply wanted pretty shots to sell from and suggested that I make them elegant, but sexy, and asked that the model look affluent and mature. Other than that, he left the results up to me and the model. In fact, he didn't even bother to come to the session.

I chose to use Laura White, one of my all-time favorite models. She is now a happily married mother who retired after over ten years of working in both print and television advertising. Laura always assimilated the part I would cast her for, whether it was a cover girl, a housewife, a working mother, the beautiful sophisticate, or a lingerie model. She always fit the bill because her own sense of self-confidence came through—to me and the camera.

We were working in a very sunny penthouse apartment and I was only able to use an 800-watt-second unit with one head and one umbrella. I wanted the feeling of natural light, but I needed the control and color balance that can only be achieved with strobe. The shutter speeds were in the longer range, from $\frac{1}{2}$ sec. to $\frac{1}{15}$ sec., to utilize as much of the available light as possible. ■

FASHION
OPPORTUNITIES

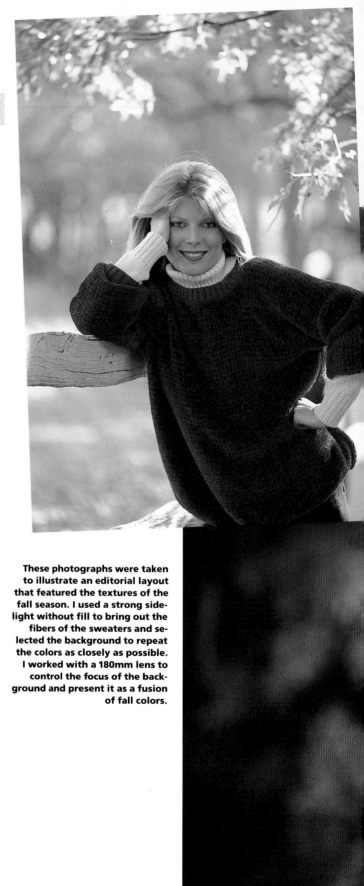

Although I don't refer to myself as a fashion photographer, I do shoot fashion on a regular basis. But because I do a number of other things, I may shoot two or three fashion jobs in a row and then not do any for a month or two.

When casting models for a fashion shoot, I look at how well a person moves. A model's carriage will make a great deal of difference in how the garment—and your photograph—will look. I like to shoot fashion outdoors. You have a great variety of lighting situations to work with, which makes the whole process a lot easier and quicker, and the models have more freedom since they are not locked into a small area.

If it is an editorial assignment, you have tremendous flexibility in your shooting. If it is for an advertisement, the parameters are directly related to the attitude of the client, which can range from the most conservative to the most innovative. It would be impossible to state definitions or rules on how one should shoot fashion. There are so many photographers with so many styles that clients and art directors in this area probably have a wider choice of talent than in any other specialty of the field.

Many clients will try to match the photographer with the line of clothing, choosing one who will deliver the look they feel is best for a particular style of clothes. Some people use the same photographers for everything they do. In fact, a number of photographers are actually responsible for creating the image for an entire manufacturer's line.

In New York City, fashion photography is probably the most crowded of all the specialties. Yet one look at the women's magazines will show you how much work is available. They're like giant catalogs filled with page after page of beautiful shots. It's for this very reason that fashion photography attracts so many new, young photographers.

Some of the photographs that follow will show how and why I work in a particular way. They will show what's best for me, but that may not be the answer for someone else. When you look through the fashion magazines, try to figure out how and why a photograph was made in a certain way, but don't try to copy it. If you try to apply a viewpoint or direction to each assignment, you will eventually find that many things become second nature to you. When you find a direction that you are most comfortable with, test it constantly. At a certain point, your technical ability will become so polished that you can apply your creative process to solving the graphic problems of the assignment. Your style will slowly evolve as you find yourself working in a certain direction. And this style will give the buyer something to recognize in your work and a reason to hire you. ■

These photographs were taken to illustrate an editorial layout that featured the textures of the fall season. I used a strong sidelight without fill to bring out the fibers of the sweaters and selected the background to repeat the colors as closely as possible. I worked with a 180mm lens to control the focus of the background and present it as a fusion of fall colors.

A sportswear manufacturer I work with frequently asked me to shoot a couple of "idea shots" for his catalog. Model Brenda Harris came by the studio a few days later wearing a jogging suit, so we went out to scout some locations. This particular construction site worked well graphically because of the colors, but we ended up working in the studio for the final shot because of the limited budget.

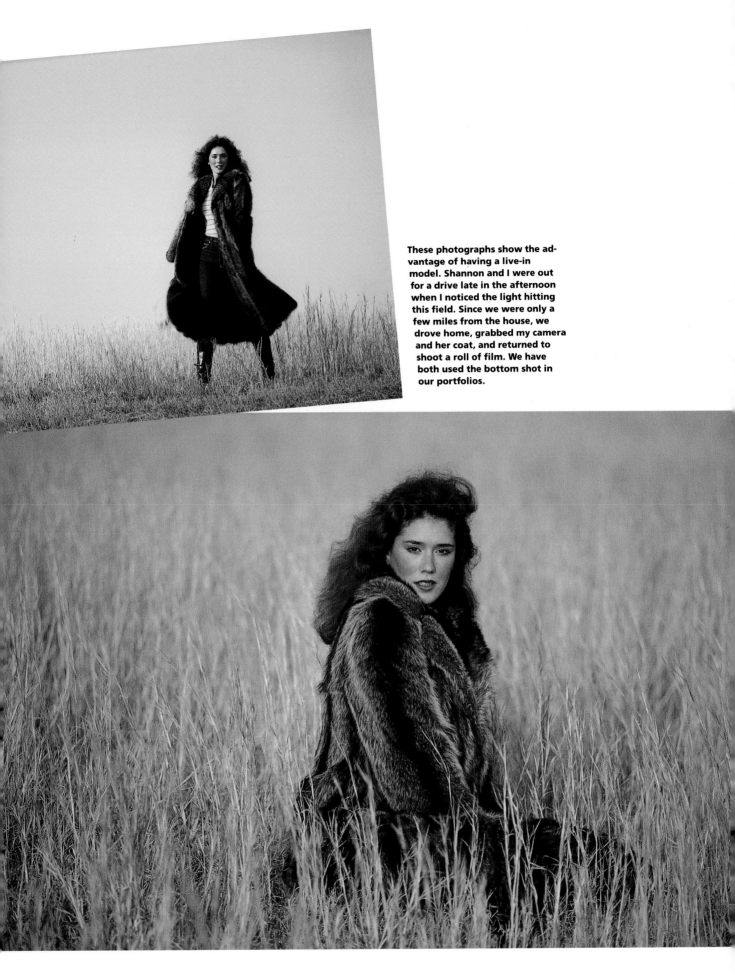

These photographs show the advantage of having a live-in model. Shannon and I were out for a drive late in the afternoon when I noticed the light hitting this field. Since we were only a few miles from the house, we drove home, grabbed my camera and her coat, and returned to shoot a roll of film. We have both used the bottom shot in our portfolios.

EDITORIAL GLAMOUR

A large portion of my editorial work takes place on location. The editors often like to add interest to a beauty feature by using a new resort or a particular type of setting as a background to the piece. It works out well for all those involved: the magazine gets an interesting feature, the hotel or local tourist board gets national advertising, and the crew gets to spend a few days working in pleasant surroundings.

This type of shooting is among the best of any professional assignment, but it's not without its problems. I'm sure most photographers would agree you work much harder on location than you do on a studio shot. This is because you have to deliver something from the shoot everyday, and there's rarely an opportunity for retakes. The combination of a new visual environment and the pressure of producing results keeps your adrenaline pumping for the 12-to-14-hour days.

Contrary to the belief of many friends and neighbors, my trips to the Caribbean with several beautiful models do not involve lying in the sun, going wind surfing, and drinking pina coladas. In reality, it usually means rising before the sun does so that you don't miss the light, working until sunset, maybe a two-hour drive back to the hotel, and then planning the next day's shoot with the editor and stylist.

Many times when on location the client becomes a little concerned about whether or not he is getting the maximum amount of hours from the photographers and models. It does cost a lot of money to transport the entire team to a location and then pay for their food and lodging. Unless he sees you working every minute of the day, he sees money seemingly being wasted.

It has been my experience that I can do most of the shooting between 7:00 AM and 10:00 AM, take a break during the hours of the harshest noon light, and then start again around 3:00 PM until the sun sets. The quality of the light at these times of the day is so much more complimentary to beauty and fashion work, but it can be difficult to explain this to the client's representative. Unless you are dealing with someone who has enough experience working with photographers on location, it becomes very difficult for them to justify in their own minds that this very expensive crew is taking four or five hours off in the middle of the day. I have been very fortunate to work with a number of people who understand photography and will listen to my advice when I plan a shoot around the sun. It also makes for a happier team—and therefore better pictures—when the crew knows that they will have a few hours to enjoy their surroundings during the day.

The greatest advantage to working on location is that these jobs are among the most creatively flexible type of professional assignments. When you are working on an editorial assignment, there will be a theme or direction that the magazine wants you to follow, but there's almost always room to improvise. It is up to the photographer to come up with some sort of cohesive approach that illustrates the idea of the feature most effectively. ∎

These photographs of model Carol Kurzin were taken as part of a beauty and hair layout for *Woman's Day* on the island of St. Croix. The photographs are perfect examples of how flattering the late afternoon light can be in this type of shooting.

The first two photographs shown were made as test shots after the day's shooting for the magazine had finished. They're simple shots, with no reflectors or umbrellas, just the late afternoon sun hitting Carol's face directly. A 180mm lens was used wide open at *f*/2.8.

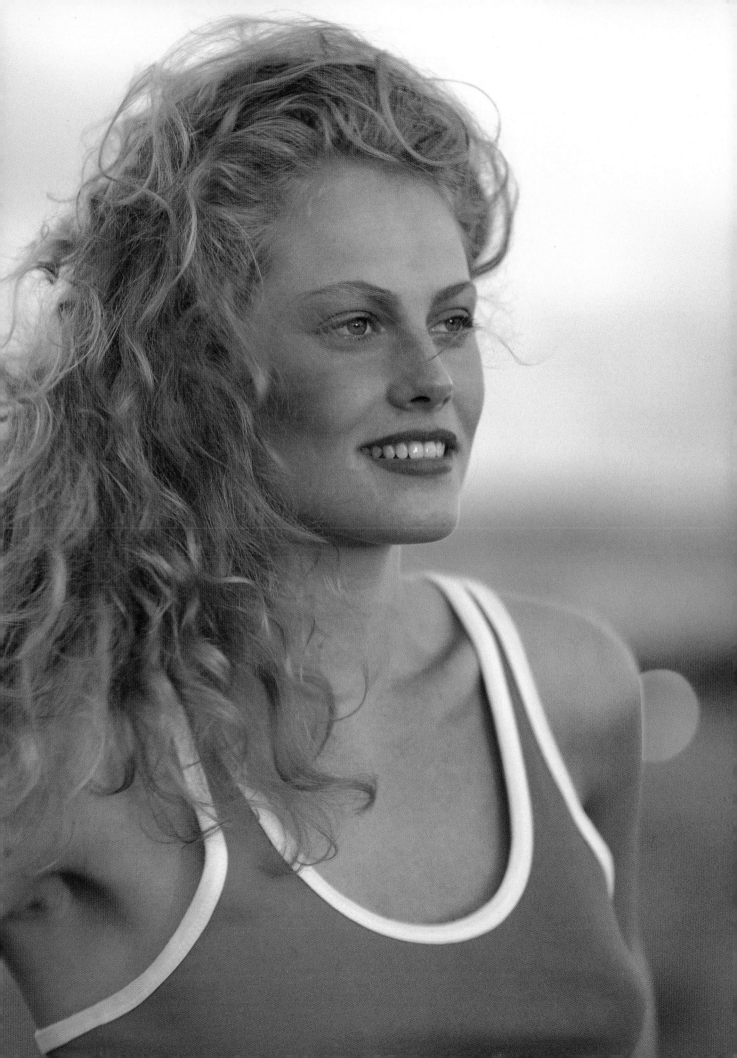

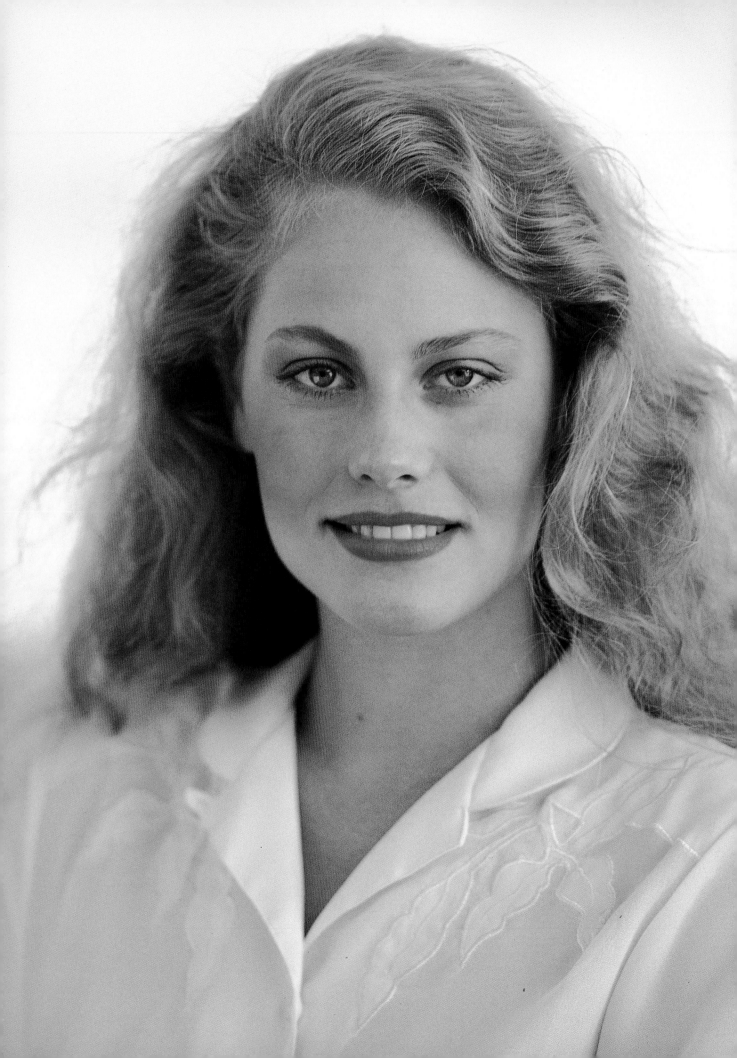

We again used the late afternoon sun directly on Carol's face, but this time it was filtered through a white translucent umbrella. There was also a white reflector placed low in front of her and to the left side, which was pulled back about three feet for softer fill light.

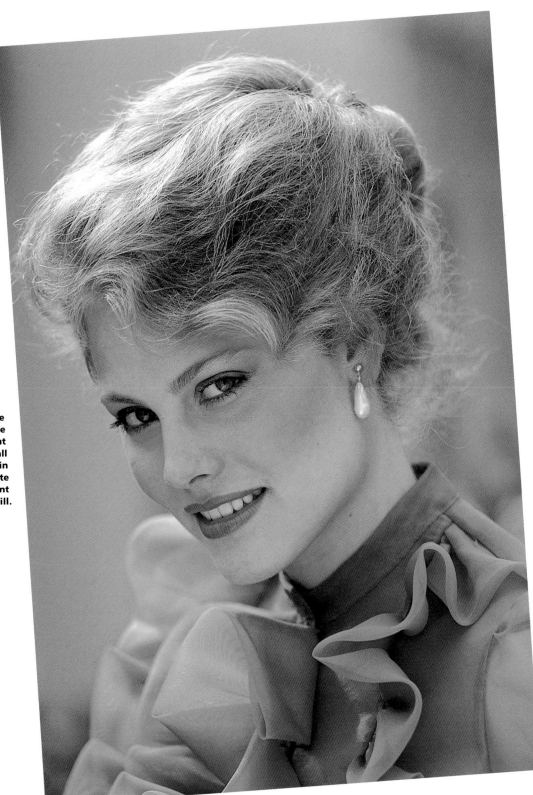

Carol's makeup and hair are more stylized here, but the lighting is still simple. Sunlight bounced off the white wall behind me, acting as the main light source, and a white reflector was placed low in front of her for fill.

BEAUTY ON LOCATION

One of the most strenuous aspects of working on location is that you have to create a large variety of images in a given amount of time. In fact, you are often shooting a number of setups in one day. You may have more than one model on the shoot, which means someone is always ready to be photographed. One girl may be with the stylist while another is working with you—and a third model may be "waiting in the wings."

These particular photographs are part of a shoot on location in St. Croix for a beauty and makeup feature for *Woman's Day* magazine. My assistant and I had to get up quite early to scout each day's location to plan the shoot around an area that provided a number of different backgrounds within walking distance of an impromptu dressing room. The model, Shari Hilton, is one of three who were featured on this shoot. The hair-and-makeup stylist is Robert La Courte. ■

These two photographs were among the first shot in the early morning to demonstrate different hair styles. I used a 180mm lens and only available light. The early morning sun was bouncing off a white wall behind me and we used one white reflector in front of the model for extra fill.

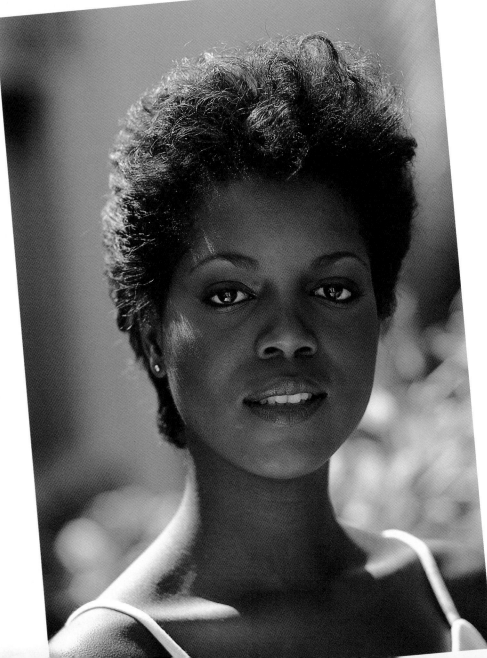

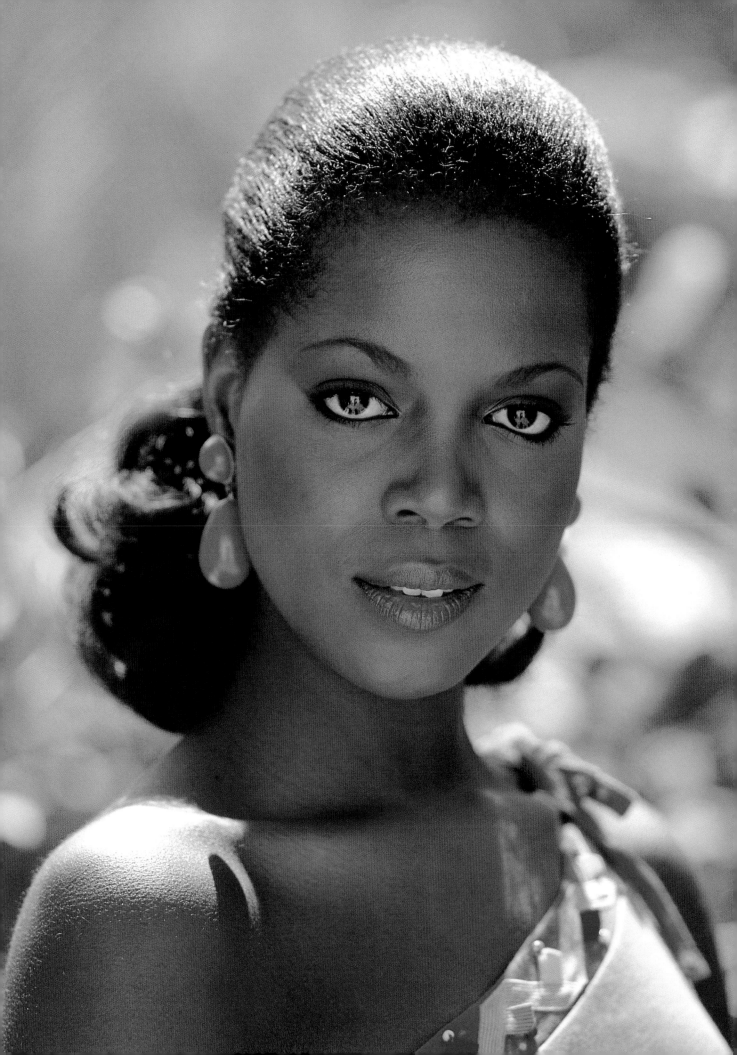

BEAUTY ON LOCATION

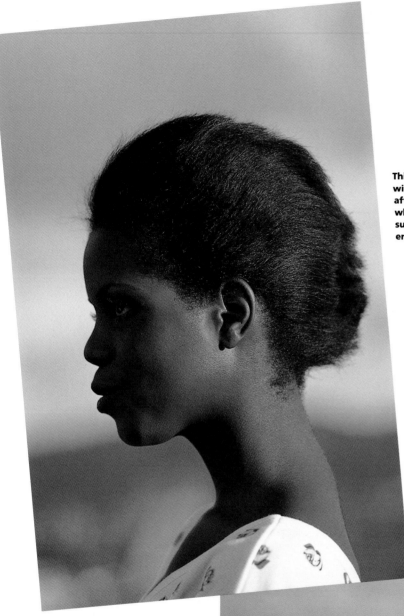

This photograph was taken with a 180mm lens in the afternoon. I didn't use any fill when working with the direct sun, as I wanted to keep all the emphasis on her hair.

This photograph was taken in the same location, but much later in the afternoon. We were actually leaving to drive back into town, but the light was so beautiful that we turned around and came back. I picked up the camera with the 180mm lens and shot spontaneously with no fill. I use this photograph in my portfolio and my rep is often asked if it was taken in Africa. I'm always pleased to hear this, as that's exactly what I had in mind when we were shooting it.

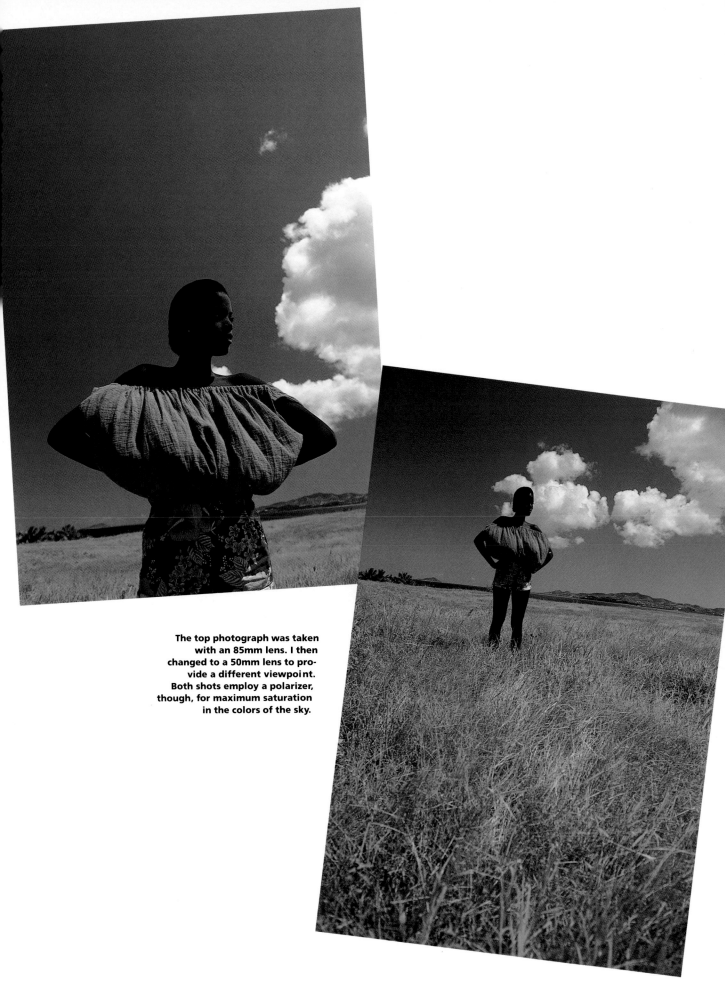

The top photograph was taken with an 85mm lens. I then changed to a 50mm lens to provide a different viewpoint. Both shots employ a polarizer, though, for maximum saturation in the colors of the sky.

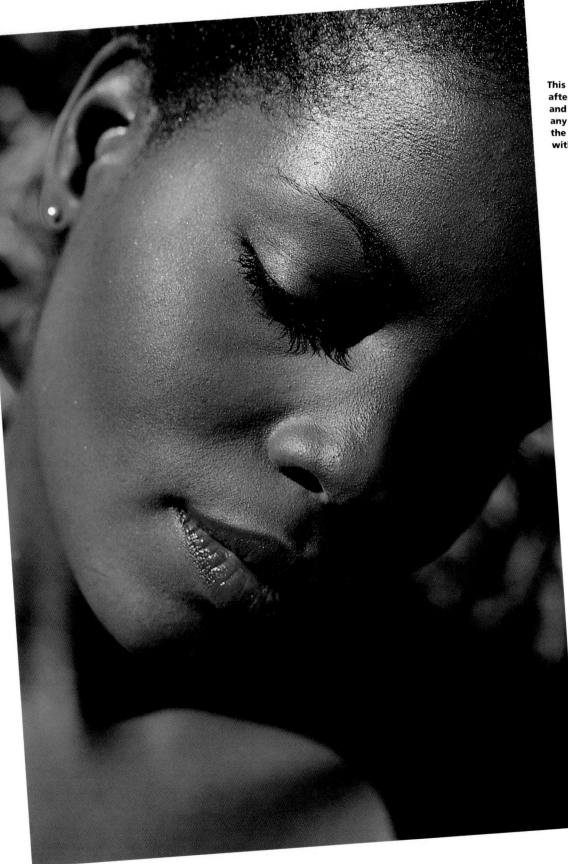

This is a closeup taken that same afternoon. It was late in the day and we used direct sun without any fill to keep the emphasis on the hair. Again, I was working with the 180mm lens.

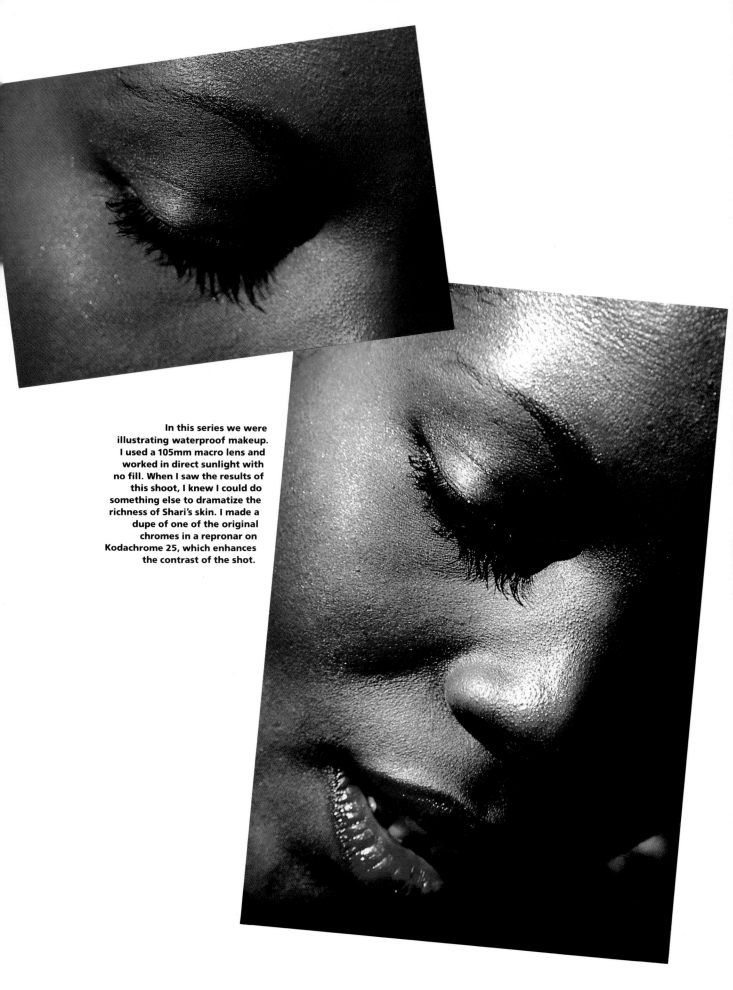

In this series we were illustrating waterproof makeup. I used a 105mm macro lens and worked in direct sunlight with no fill. When I saw the results of this shoot, I knew I could do something else to dramatize the richness of Shari's skin. I made a dupe of one of the original chromes in a repronar on Kodachrome 25, which enhances the contrast of the shot.

TRAVEL STORIES

I have photographed women all over the world, and while I always try to capture some of the indigenous quality in their beauty, I have found that it is still the individual qualities of the person that should show through in the final photograph. Of course, there are the usual parameters, as with every job, but a photograph taken to illustrate travel will have the additional element of needing to offer the viewer a sense of place. This can be created very simply with the inclusion of a distinctive landscape or landmark, or it can be a subtle illusion reflected in the mood or manner of the model. ▪

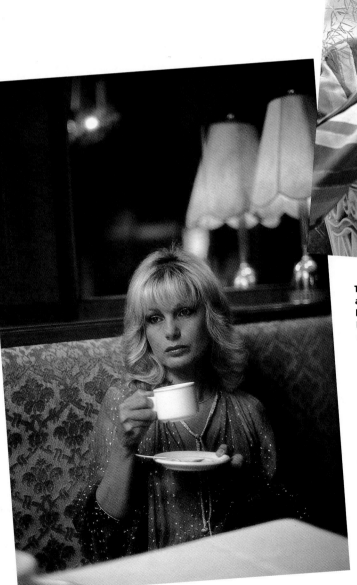

These photographs were taken as part of an assignment illustrating Viennese coffee houses. While working inside one of the city's older establishments, I shot a few candids during a break. I felt that I had captured the mood I wanted in this photograph—Vienna struck me as very much a city of the past, very sad, yet very romantic. I liked this shot very much, but my rep disagreed, the editor disagreed, and the art director disagreed. So we moved outside to the sidewalk cafe for a change of clothing, a change of light, and a change of mood. My rep liked this shot, the editor liked this shot, and the art director liked this shot. It was also the shot that was finally used for the article.

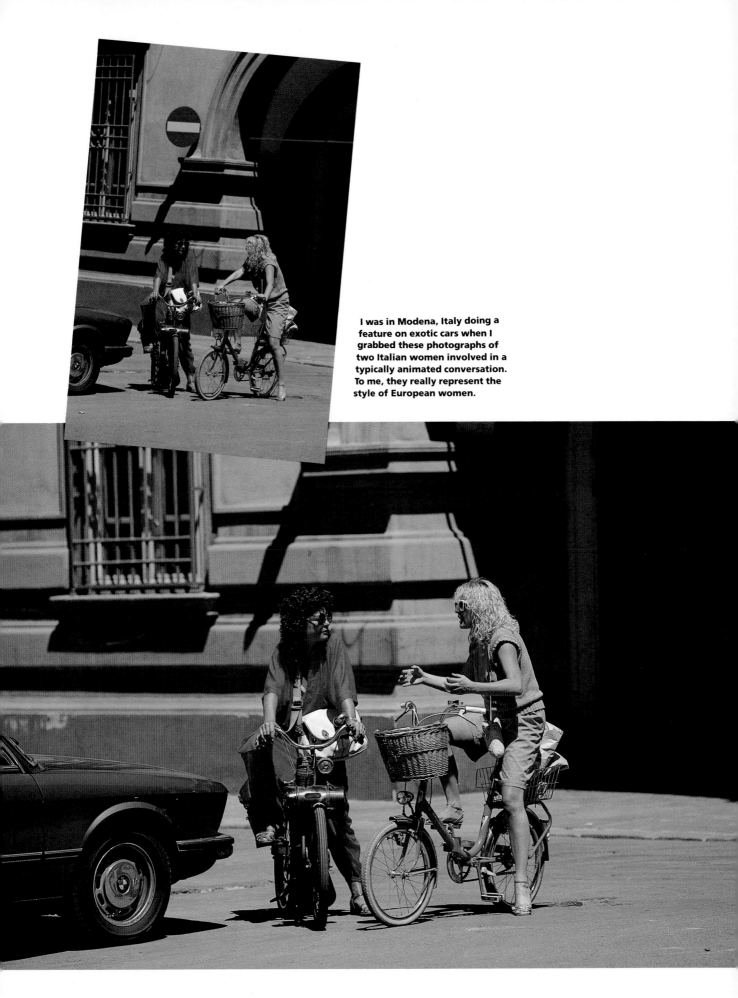

I was in Modena, Italy doing a feature on exotic cars when I grabbed these photographs of two Italian women involved in a typically animated conversation. To me, they really represent the style of European women.

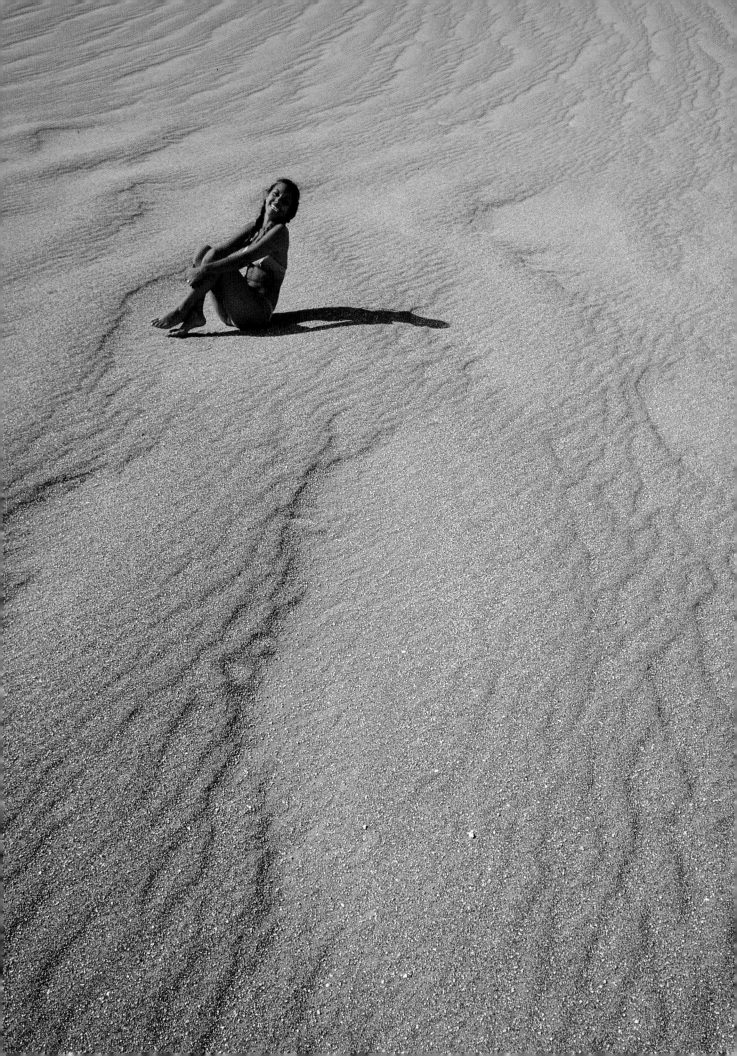

This photograph was taken in the Vally of the Moons in the Atacama Desert in northern Chile. The model is Marca, who was my Chilean guide for the trip. The assignment was to photograph around the country for a 64-page tourism booklet.

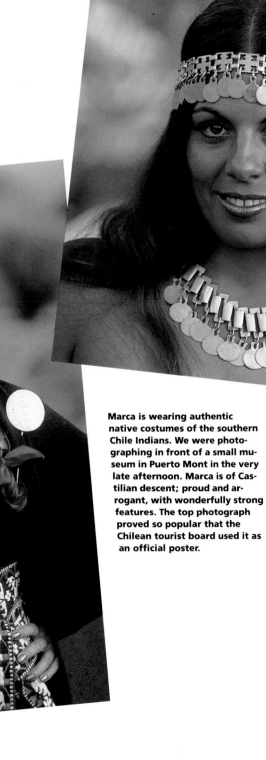

Marca is wearing authentic native costumes of the southern Chile Indians. We were photographing in front of a small museum in Puerto Mont in the very late afternoon. Marca is of Castilian descent; proud and arrogant, with wonderfully strong features. The top photograph proved so popular that the Chilean tourist board used it as an official poster.

SHOOTING WITHOUT THE CLIENT

As difficult as it may be having a client on location with you, one of the problems of working alone on location without the benefit of client approval is making a decision everyone will be happy with. Such a situation occurred when I was asked by *Newsweek* to do a cover shot for a major story on Hawaii a few years ago.

I left New York City with the client's request to take a photograph of a native girl by a waterfall. When I arrived on the island of Oahu I faced a serious problem. The islands had been experiencing a drought for several months prior to my arrival and most of the falls on Oahu had little or no water in them. Luckily, my hotel doorman told me that he was from the island of Molokai, and the Hipuapua Falls near the village of Halawa always had water.

In the meantime, during my location hunt on Oahu, I had met a shoe salesman (I had forgotten to pack my tennis sneakers) and hired him and his girlfriend, who was a native and a flight attendant on one of the local island-hopping airlines, as my models. The magazine had asked that I try to use "real people" and not hire professional models.

I flew over to Molokai and scouted Hipuapua Falls, which required a forty-five minute climb up a small mountain and through a lot of red lava mud. I then found a hotel where I could spend the night and had the models come over on the 7:00 AM flight the next morning. After the shoot, I was able to get back to Oahu in time to put the film on a 4:00 PM flight to New York City for the editors to approve.

The next morning I received a call from the *Newsweek* editors. "Forget the falls," they said, "We've got another idea for the cover." I asked if they knew that it was 4:00 AM in Hawaii and if they had seen the film yet. They answered no to both questions, but "Forget the falls, we want you to shoot a luau."

This went on for five days. I would get 4:00 AM calls every day, each with a different cover idea before anyone had seen the previous day's material. The final shot used for the cover was something that I could have taken at the Brooklyn Botanical Gardens! ■

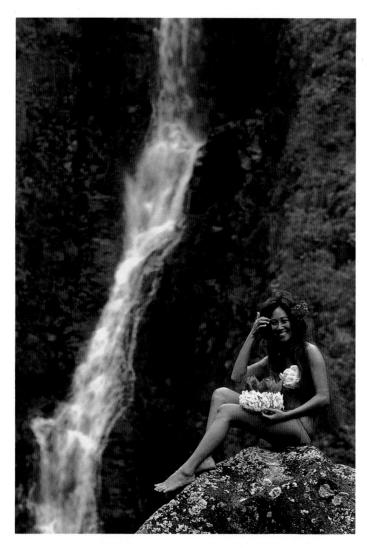

These two photographs were taken from the first ill-fated cover shoot. Both were shot with natural light. An 85mm lens was used for the photograph shown above, while I changed to a 50mm lens for the view on the opposite page. Extra care needs to be taken when working in a situation that may include a canyon, waterfall, or any enclosed area where lighting is mostly from the top. If careful meter readings are not taken, you can end up with well-exposed foreheads, noses, and shoulders, but totally black eyes. To the untrained eye, the scene can be very beautiful, but the surrounding trees, dark stone, or earthen walls will absorb almost all of the bounced light that would normally act as fill.

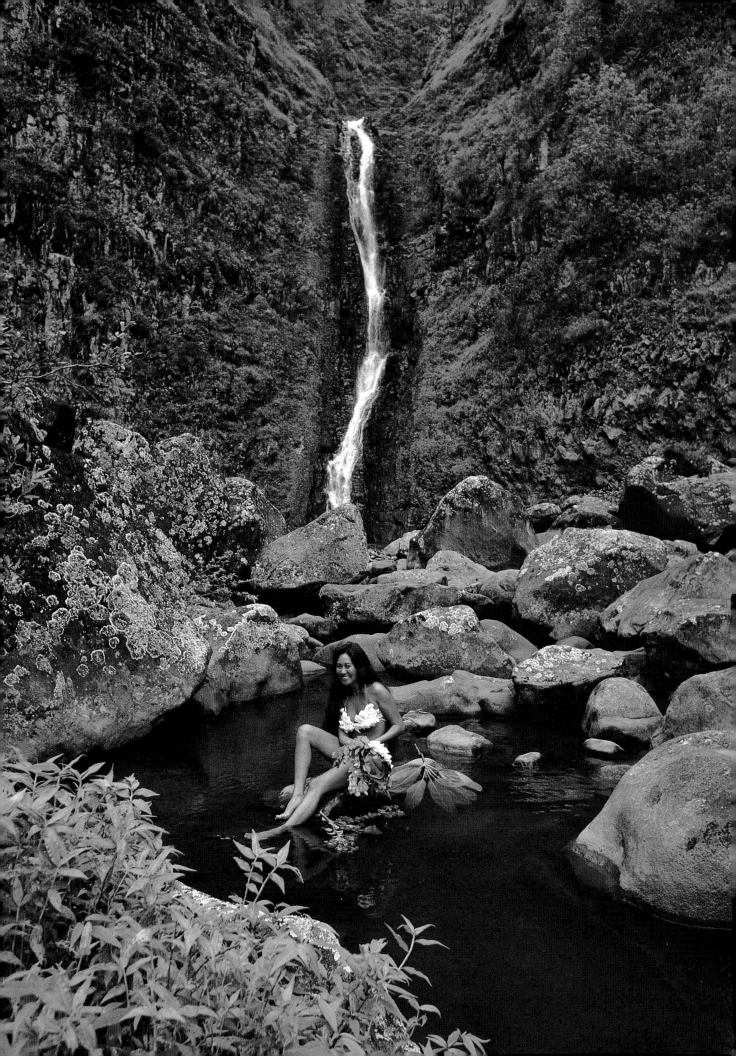

LAST MINUTE CHANGES

*A*nother assignment for a cover story for *Newsweek* resulted in one of the few reshoots I've ever had to take. It's a classic example of what can happen when the client isn't there on the shoot—and how capricious the demands of a client can be.

The assignment was to illustrate a feature story on the Club Med vacation resorts in the Caribbean. I was to bring one model (selected by the client without my input) with me to the island of Guadeloupe who would spend the first four days of the trip getting a tan in preparation for the cover shot. I love all the models I've ever worked with, but in New York City in the middle of winter they will claim to be an expert on anything—horseback riding, water skiing, you name it—if it means getting to spend some time in the sun.

The model claimed that she would have a deep, dark tan in four days. By the sixth day all she had was this wonderful, blotchy, reddish-pink skin—but she was having a hell of a good time! I was able to use her in a number of shots, but the writer and I knew that we had to find someone else for the cover. We ended up using two people who worked there at the club; she was a nurse, and he was a sort of public relations man—a jack-of-all-trades—which seems to be the rule of thumb for all employees of Club Med.

We set up the shot late in the afternoon to take advantage of the warm light. I used a 500mm mirror lens for most of the shots, switching to a 200mm lens when there was too much wind for the 500mm. When I returned to New York City, I was confident I had a cover shot that said what I wanted.

Two and a half weeks later, *Newsweek*'s art director called me and said he wanted me to go back and reshoot the same cover shot—with a few changes. It was Friday, December 19—the beginning of Christmas vacation time in the Caribbean—and flights to the area had been booked solid for over six months! I thought he was kidding, but he was serious. *Newsweek* always goes for a strong cover for the first-of-the-year issue to compete with *Time*'s "Man of the Year" at the newsstand, and the Club Med article was to be featured on that year's January 1 cover.

What was their problem with the original shot? They thought it was too sexy. They asked that I put some sort of top on the model, raise her pareau further up the hip line, remove her necklace, take the drink out of his hand, and finally, change the position of his pareau because they thought the placement of the pineapple was too suggestive. Now I really thought they were kidding! But no, those were the changes.

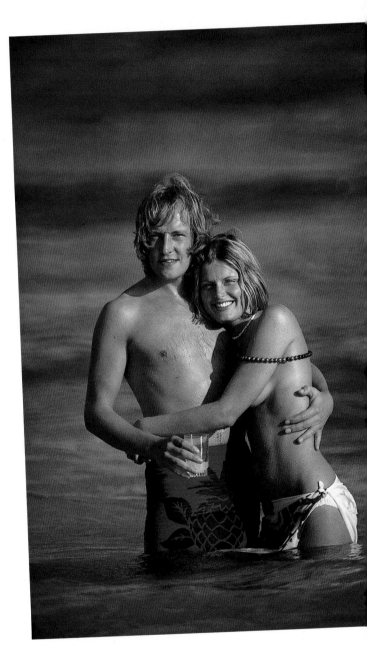

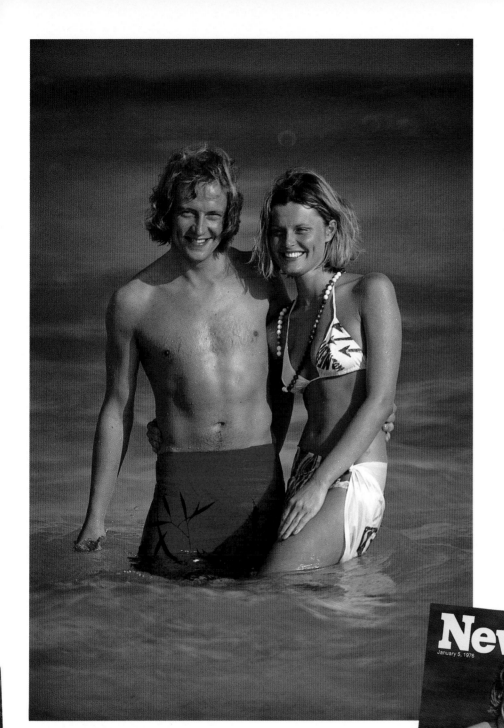

My staff and I got on the phones and called every airline that flew to the Caribbean. When we said that I needed to get to Guadeloupe the next day, most of the ticket agents just laughed. The magazine couldn't help us, but suggested that if I could get to Puerto Rico, I might be able to charter a plane for the rest of the trip. They really wanted that reshoot badly.

For a while I was planning to fly from New York City to Atlanta to New Orleans to Martinique, and then swim the rest of the way. But Club Med came through with a cancellation for a flight the next day. The models picked me up at the airport and we were shooting an hour later. I reshot the cover at sunrise, and once more in the afternoon, and was back on the streets of Manhattan that night. I understand that *Newsweek* did well against *Time* that year, even though my original photograph wasn't on the magazine's cover. ■

COVER ILLUSTRATION

When I'm photographing a magazine cover in the studio or other indoor locations, I'll usually offer the art director a few more variations than are possible when working outdoors. In the studio I don't have to worry about the light fading, or the wind kicking up, so I'll take the time to move in for a closeup, try a different angle, or add more of the background.

This assignment was to illustrate caviar for *Signature* magazine. The art director and I decided not to go for the standard closeup food shot for the cover. We thought it would be better to set up the scene of a very sophisticated woman in an elegant restaurant. We worked with model Laura White and she was perfect for the image we were trying to portray.

I wanted to work with a very warm lighting setup to best illustrate the cozy, intimate lighting of the posh restaurant. The main light consisted of a double umbrella and an 800-watt-second strobe. The umbrellas were placed facing each other on either side of the strobe. The strobe head was fired through the umbrella that faced the model. The whole setup was positioned slightly to the left and behind the camera. Another head was bounced off the ceiling to light the rest of the scene. A third head, consisting of one 400-watt-second unit, was directed at the model from behind and to the right to provide separation between the model and the background. I used a shutter speed of ⅛ sec. to pick up the warmth of the lighting, while the strobe determined the aperture. ■

This was the first photograph of the shoot. We went for a wide view showing more of the restaurant interior.

We then moved Laura to another table so that I could pick up the wall sconce in the background. I moved in for medium and then tight shots. We felt that this setup was more intimate and in line with the art director's needs for a good cover shot. I prefer the photograph with the soft-focus, but as you can see, it was not the final choice for the magazine's cover.

134

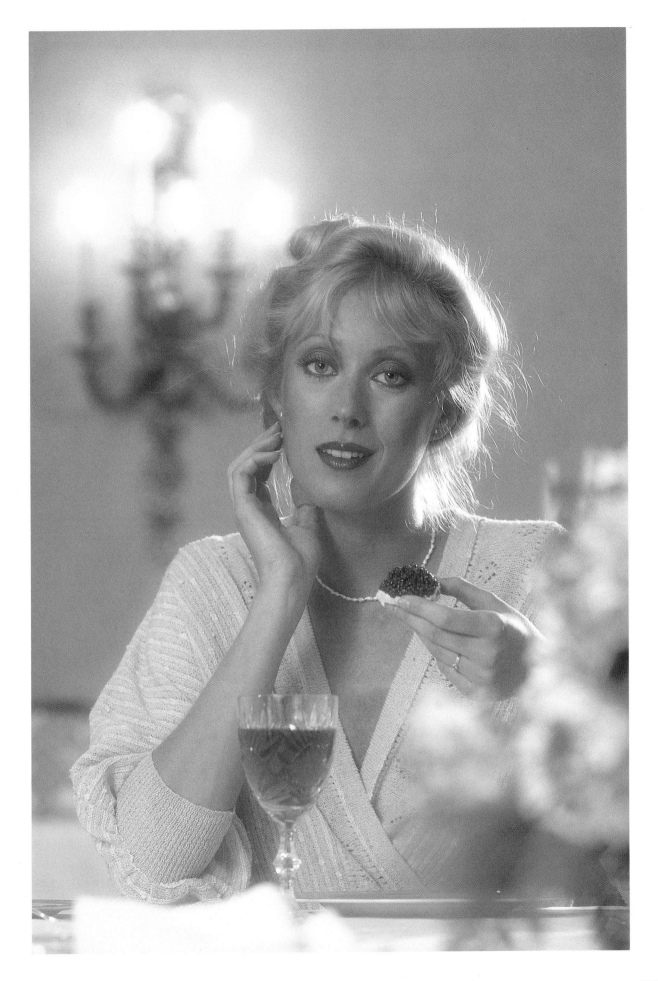

COUPLE DYNAMICS

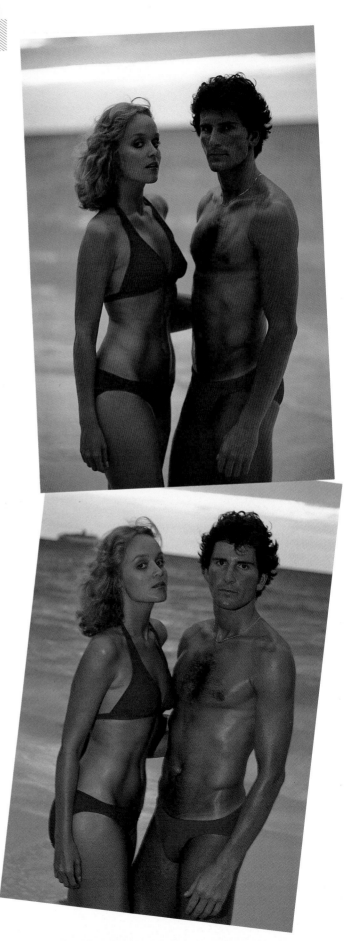

Although the emphasis thus far has been on photographing women, there are many occasions when the beauty photographer will be asked to photograph couples. A male model is often added to a beauty or fashion shot as "window dressing," an additional prop to add interest to the setting.

The most important part of working with couples is casting. This goes beyond the obvious choice of hiring two good-looking people—if you have to work with a couple who are to convey a close relationship, it is best if they can relate to each other. Nothing is more difficult than trying to work with two people who can't stand to touch each other. When working with couples, I insist on being involved in the final model selection. If I am expected to deliver photographs that reflect a particular mood, then it is necessary for me to work with two people who can project an image of a warm relationship.

Some of the most terrific female models in the business have trouble working with a man because they are used to doing singles. It becomes impossible for them to share the spotlight. When I put two people together, I look for people who will naturally touch, laugh, talk, gesture, or display any of the normal reactions anyone would have when placed in these situations. Whether it's walking on a beach, having a drink, or simply standing around talking— if the contact is forced, it will look false to the camera.

When I cast male models, I rely on the opinions of the female members of my staff. I ask if they think a particular model is too pretty, too macho, or maybe just not very appealing. Most of the male models I use have become good friends of mine over the years. I know what type of work to use them for and what they can deliver in a given situation. For my purposes, the best male models enjoy being in the company of women. They project this to the camera without any direction beyond my initial instructions describing what I am trying to convey. ■

A good friend and long-time favorite model is Phil Cocheletti, seen here with Kathy Padin. Phil is primarily working in film and television these days, but he would always be up for a shot and made the clothing look great.

This is one of those "end-of-the-day" shots that involved a little baby oil and just the right light. To be perfectly honest, this is also an example of what can happen when the models just aren't relating well to each other after working together all day. We were at the end of a long day of shooting and I went **too far asking for "just one more." Everyone was tired—as I said, when something is forced, the camera can't hide it.**

While we were taking this series, one of the members of the crew was standing on the side taking a few snapshots with her Instamatic. I quickly borrowed the camera and my assistant took a Polaroid test to calibrate the exposure using her little built-in flash as a fill light. The f-stop was determined by her flash and speeds, as low as ½ sec., were determined by reading the setting sun.

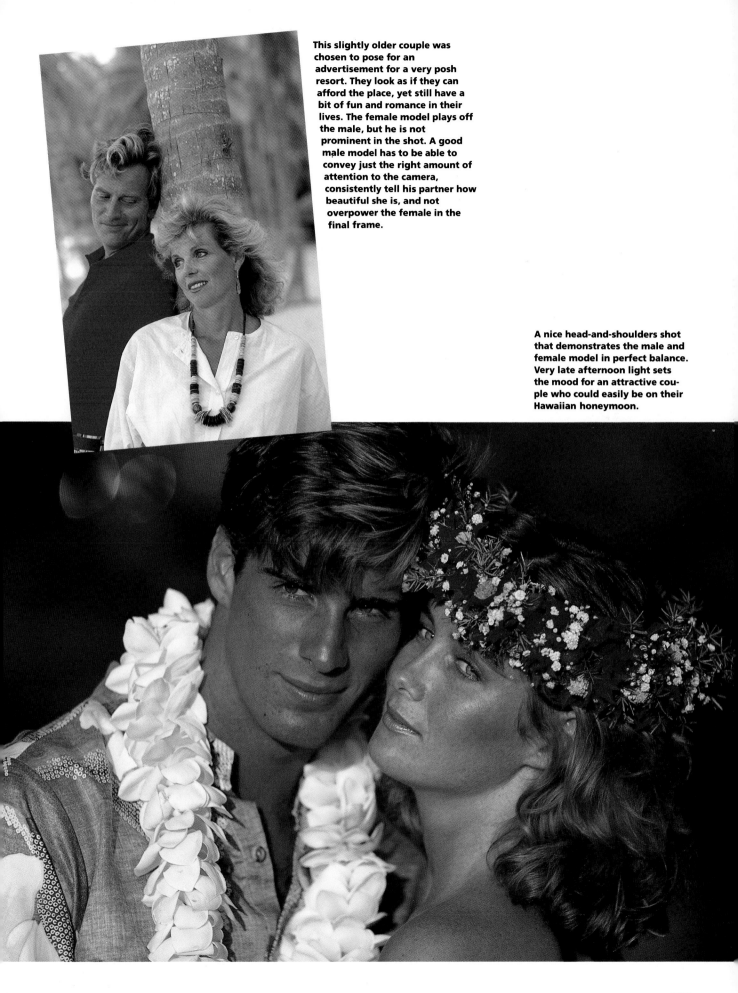

This slightly older couple was chosen to pose for an advertisement for a very posh resort. They look as if they can afford the place, yet still have a bit of fun and romance in their lives. The female model plays off the male, but he is not prominent in the shot. A good male model has to be able to convey just the right amount of attention to the camera, consistently tell his partner how beautiful she is, and not overpower the female in the final frame.

A nice head-and-shoulders shot that demonstrates the male and female model in perfect balance. Very late afternoon light sets the mood for an attractive couple who could easily be on their Hawaiian honeymoon.

THE NUDE
IN THE STUDIO

Photographers are frequently asked to interpret the nude in advertising or editorial layouts related to beauty products. The problem in taking these photographs is keeping the shot from becoming too suggestive, while still conveying the mood the client has in mind. This is especially true of lingerie photographs because some manufacturers want to appeal to a very conservative audience, while others want to capture the young independent woman who is interested in a more sensuous look. The control of the end result usually rests with the photographer and depends on how he relates to the model and how the model relates to the photographer and the situation.

After the set, lighting, and mood have been agreed upon by the interested parties, it is up to the photographer to get the right reaction from his subject. This is among the most delicate of photographer-model relationships, and it is very important for the photographer to have a say in the casting of this type of shot.

We run into difficulty when any type of nude or semi-nude photographs are requested, because there is a marked increase in the number of people, from the client's office and the ad agency, who suddenly find a reason to be at the shoot. It is quite difficult for a model to feel comfortable or uninhibited when the audience is unnecessarily large. We try to control this pretty tightly and I would recommend that any photographer just starting on his own do the same. The model may be getting paid as much as $1000 an hour, but that doesn't mean you're running a peep show. ■

We recently built a new studio in a large loft in the Soho district of Manhattan. I worked with the architects to build in various conveniences that I have always wanted for studio work. First, we designed a large area that can accommodate three shoots simultaneously. Second, I requested a large kitchen for both food preparation and food shots. We added a projection/conference room, a separate film-loading room, and a big dressing room with available light. We also added a prop room, a tool room, large darkrooms, and, last of all, a shower that I could shoot into without being in the bathroom. That way, when the next bath oil or shampoo shot came up, I wouldn't have to set up the kiddy pool, run the hoses, and generally make a mess of the studio as we had in the past.

The shower is built into a corner of the bathroom that extends out into the large kitchen area. The two outside walls are sheets of safety glass and there is a glass door on the inside. Now we can shoot into the shower from any one of three sides and light through the other two without getting wet or worrying about wet strobes, which can be dangerous.

These photographs of Candace were made with two heads, one firing through an umbrella hitting her with sidelight, and the other actually placed in the bathroom with a green gel lighting the wall.

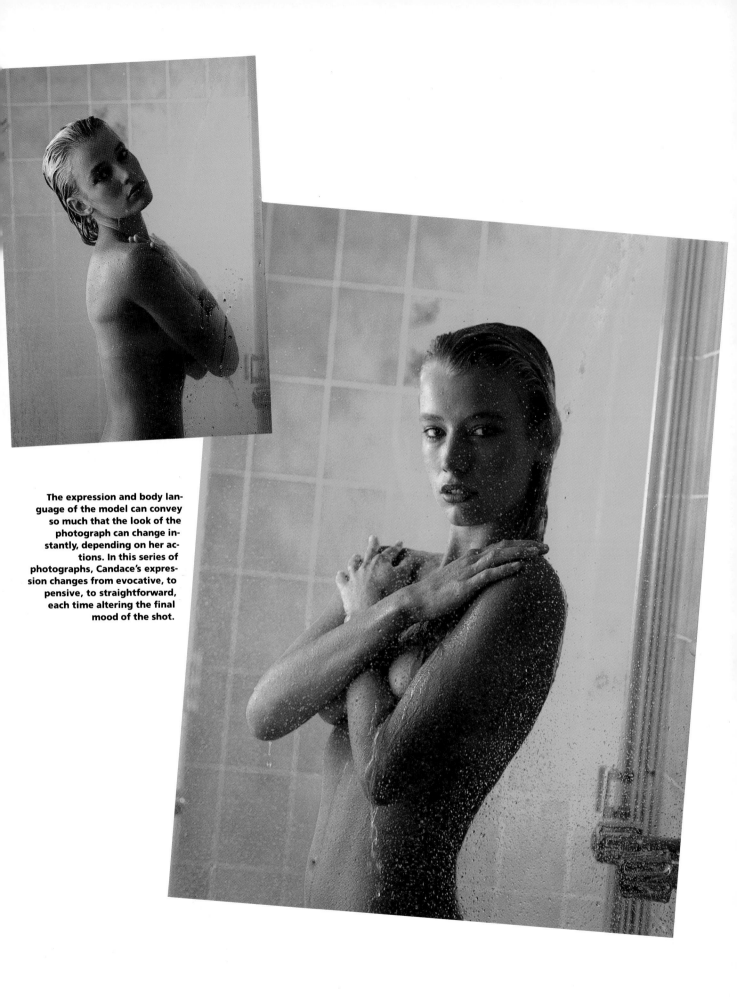

The expression and body language of the model can convey so much that the look of the photograph can change instantly, depending on her actions. In this series of photographs, Candace's expression changes from evocative, to pensive, to straightforward, each time altering the final mood of the shot.

NUDE BEAUTY ON LOCATION

To me, a well-planned shot of a semi-nude model with little or nothing showing is far more provocative than a total, explicit nude. This shot, taken for the South American airline Aero Condor, is a good example of just how effective such photography can be.

We were looking for something other than the normal travel shot. The location is San Andreas Island off the Caribbean coast of Columbia. We had been shooting in Cartagena for a few days, but didn't come up with any "grabbers," so we flew out to San Andreas.

I could see this little island, about the size of a football field, off the coast of San Andreas. I thought if we could get closer to it, we would have a nice background for a very pretty shot. I finally found a pig farmer who would take us out there on his boat. He dropped us off and said he'd be back in three hours. The three hours turned into five, but if you're going to be stranded somewhere, it might as well be on a small Caribbean island with a beautiful lady. (I guess I should mention that two client's representatives were with us as well).

Prior to leaving New York, I had asked the model, Diane Hawkins, to pick up a flesh-colored bathing suit, thinking that a shot like this might present itself. The suggestion that she is skinny dipping adds a lot of impact to the photograph.

I wanted the island to carry in the background of the shot, so I had to move waist deep into the water and use a 50mm lens. It was quite windy, and the waves were knocking both the model and me around. Occasionally both my camera and I were drenched (again, I was carrying my rugged old Nikon F). It took half a dozen rolls of film before I felt I had the shot I wanted; I did some experimenting with longer lenses, but none of the photographs were as successful as this one.

The photograph was used as an Aero Condor poster (called "Hawk Key" by the client since I had nicknamed Diane "Hawk"), and it was very much in demand. In fact, a number of them "disappeared" from the various airports where they were displayed. ■

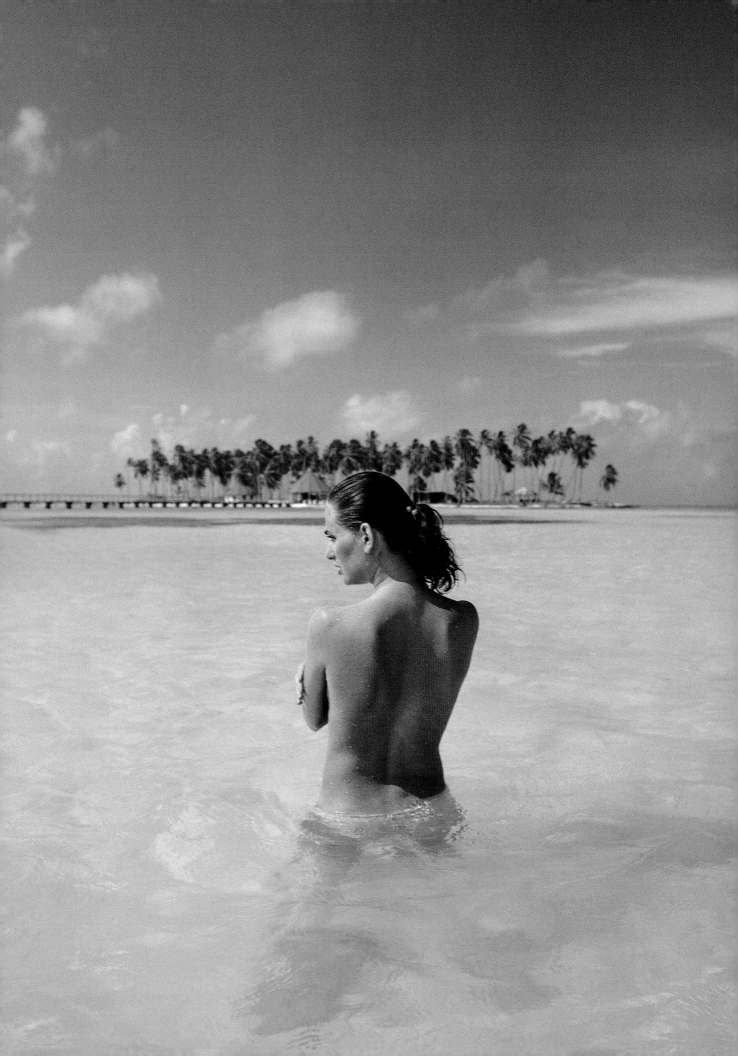

INDEX

Editorial Concept by Marisa Bulzone
Edited by Donna Marcotrigiano and Robin Simmen
Designed by Jay Anning
Graphic Production by Hector Campbell